INTRODUCTION TO

THEATRE

SECOND EDITION

ELIZABETH BOJSZA

JEANETTE OI-SUK YEW

CATE CAMMARATA

• • •

Stony Brook University

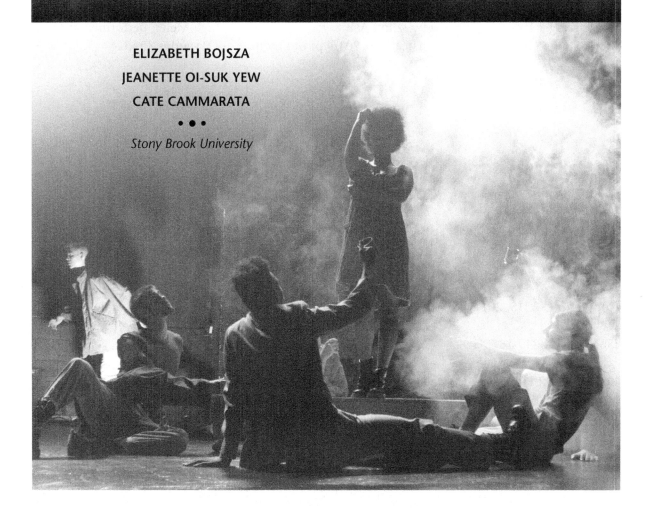

Kendall Hunt
publishing company

Cover image: *Woyzeck,* directed by Izumi Ashizawa, translated by Inga Meier, performed at Stony Brook Staller Center for the Arts Theater 1, 2016, photo by Jingwen (Wendy) Zhao.

Kendall Hunt
publishing company
www.kendallhunt.com
Send all inquiries to:
4050 Westmark Drive
Dubuque, IA 52004-1840

Published in the United States of America

Contents

Introduction

∙∙

n the following chapters of this book, you will study and develop your own aesthetic experiences with the specific art form of theatre. To that end, we will be introducing you to a diverse set of examples of theatre—ones that differ in the nature of their performances and also in the way theatre artists created them.

This book is designed to meet you where you are, whether you are someone who has had extensive theatre experience as an audience member or a participant, or if you have never seen a play before. Because we don't assume any prior experience or want to discount it, we have made every effort to keep this book as jargon-free as possible without watering down any concepts. We also have made every effort to activate and validate your critical thinking as a capable investigator of this art form.

This textbook and the course of study it accompanies do not endorse any type of theatre as superior over any others. Admittedly, our case study examples are subjective; we chose them because of our prior familiarity with them, but every attempt has been made to present the diversity of theatre without ranking or value judgment. We start with examples of narrative theatre with strong conflicts and move to examples unified by theme or other more abstract forms as you gain proficiency in the objectives of the course—not because narrative theatre is "easier" than other forms, but because most people will find the storytelling accessible and therefore can more readily move beyond comprehension of content into analysis of form. Complexity should not be conflated with difficulty. Instead of thinking of the case studies in this book as analogous to "reading levels," we prefer to frame them as a "buffet" of sorts. We want you to experience different tastes and to broaden your palate—to experience new things and then to decide for yourself what types of theatre you prefer.

This is more of a workbook than a conventional reference textbook. We have included case studies, interviews, and skill building pages alongside worksheets and extra white space for you to populate with your own notes and reflections. Engage with this book as you complete your assigned reading for class, answering the questions posed to you as you go along. If there is an unfamiliar word to you, look it up and jot down the definition in the margin. If you are having trouble understanding a concept, "google" it and see if it helps you with your understanding, and keep a record of what you have learned. Move at your own pace and use the text in tandem with multimedia examples and any other supplemental reading and viewing assignments. Please make sure to bring your book with you to every class, as you will be able to take notes right in the book itself for class lectures and activities.

Theatre and the Aesthetic Experience

66 *Art is the imposing of a pattern on experience,*
and our aesthetic enjoyment is recognition of the pattern. 99

—Alfred North Whitehead

> About the speaker:
>
> In your own words:

66 *Any great art work ... revives and readapts time and space,*
and the measure of its success is the extent to which it makes
you an inhabitant of that world—the extent to which it invites
you in and lets you breathe its strange, special air. 99

—Leonard Bernstein

> About the speaker:
>
> In your own words:

66 *All aesthetic judgment is really cultural evaluation.* 99

—Susan Sontag, *Reborn: Journals and Notebooks,* 1947–1963

> About the speaker:
>
> In your own words:

 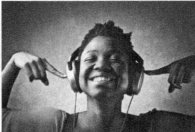 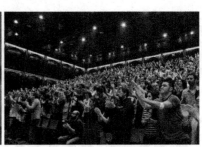

© Shots Studio/Shutterstock.com © Ollyy/Shutterstock.com © Christian Bertrand/Shutterstock.com

Each picture above shows an analogous event: a person or persons interacting with art. We have all had experiences relating to art in which we felt something deeper than appreciation—where we were "moved" in some way. It could be that the piece made us have an emotional response, or it catalyzed some personal insight, or it raised deep questions, or any combination of these.

Perhaps this hasn't happened with you and the art form of theatre (yet!), but think of your favorite painting, song, or film. You began by looking or listening very closely—observing the shape of lines, the color, the rhythm, the instrumentation. As a result of a close observation of art, we begin to create our own meaning—it could be as concrete as narrative, or as abstract as contrast, tension, or balance. When that meaning resonates with what we feel is part of our experience of being human, we have had what is called an **aesthetic experience**. In other words, we have related to that object or performance *as* a work of art.

Art is not just about beauty—though that is a valid and rather classic definition of art. It can also be about ugliness. Art can elicit the full range of emotions from awe to joy to disgust, to loneliness to comfort. It can cause us to feel regret, hope, longing, empowerment. It can raise questions about society, religion, politics, free will, and more.

Let's look at an example. Please look up the lyrics to Gloria Gaynor's "I Will Survive" (and if you've never heard it before, you might want to have a listen through YouTube or another Internet source).

Describe the music. What is the tempo like? What instruments are used? What does the singer's voice sound like?

What story do the lyrics tell?

Follow up: How do the music and the lyrics work together to tell the story?

While our individual analyses differ somewhat, most of us will agree that the story being told is from the point of view of a woman who has been through a difficult breakup, and she is now faced with her ex wanting to return into her life. Rather than accept him back, she chooses her independence and self-reliance. Musically, the song transforms from a rather quiet and slow beginning without much instrumentation to a triumphant crescendo of volume and tempo, and a drumbeat that may make you want to dance.

You realize as the speaker in the song gains confidence, the song gains momentum, and the vocals, lyrics, and instrumentation work together to create what has become a survivor's anthem. Perhaps you have had personal experience that makes you identify with the speaker (in which case singing along with Gloria Gaynor can create a feeling of confidence in yourself as well), or perhaps you just admire her resiliency and strength in the face of heartbreak. Either way, once you listen closely and link the tone and story of this song to the common, yet no less painful, human experience of heartbreak, you have related to Gaynor's hit song as a work of art.

WHAT IS ART?

When most people think about art, what comes to mind is visual art—and probably something well known and incredibly precious in terms of its monetary value—The "Mona Lisa" painting by Leonardo Da Vinci, or Michelangelo's sculpture of "David," for example, which were both created during the Renaissance in the 1500s. These works were prized for their detail and symmetry. Mona Lisa's expression has intrigued viewers for centuries and David looks so lifelike that he could walk right off his pedestal. We associate art with carefully curated and protected museums, but art can also be found on the walls outside of the museum.

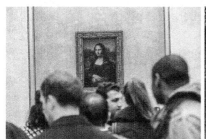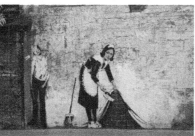

The Mona Lisa by Da Vinci, hanging in The Louvre Museum in Paris; a work by enigmatic street artist Banksy; Mural art at East Williamsburg in Brooklyn on November 4, 2014.
Left image © S-F/Shutterstock.com; Middle image © BMCL/Shutterstock.com; Right image © Leonard Zhukovsky/Shutterstock.com

A painting may be entirely visual, and music may be entirely auditory, but there are types of art and specific artists that engage audiences in multi-sensory experiences. An example of one such artist is Zimoun, who is world-renowned for his kinetic sound sculpture installations. He uses multiples of simple objects set in motion to engage with the audience's vision and hearing.

Access http://www.zimoun.net and find a work that interests you.

What is the work's title and how would you describe it?

Following are what some Introduction to Theatre students had to say about experiencing Zimoun's work firsthand. They are reactions to a piece titled "175 prepared dc-motors, filler wire 1.0mm, 2015 Motors, power supply, steel, aluminum profile" (Zimoun, 2015). In each, UNDERLINE the observations and put a BOX around the explanations of meaning. CIRCLE any mention of the audience's relationship to the artwork.

———◆———

"When observing this live installation a sense of immediacy and accessibility arises. The piece can be experienced from whatever angle and from whatever distance. Interestingly, the piece looks very different when viewed from the side than when it is viewed from the front. This type of freedom in terms of spacing lets the audience thoroughly explore the art piece and experience it from different angles and perspectives. . . . The sound generated from the wires could be reminiscent of heavy rain in a rainforest, yet there is an industrial sound element present, which results in an interesting combination. The running motors attached to the wires create a great complexity of wave like movements."
—Charlot Daysh, senior journalism major and exchange student from Norway

"For this work, the artist strung up filler wires across the top of a metal support frame. The motors powered the wires to vibrate off one another out of sync. The movement seemed natural enough for a vibrating coil, but the sound was . . . the most interesting aspect. The lack of unity in movement and that intense reverberation produced a sound which seemed like a swarm of bees was flying out of the wall, or a wave crashing onto a beach as the water recedes."—Jason Orban, junior history major

———◆———

Here are reactions to the installation as a whole:

———◆———

"As an audience member, I realized there was clearly nothing I could do to disrupt the art. There was a general understanding that the art had a job to perform and it was my job to come to my own conclusions about what it was trying to communicate. At the same time, the art performed without knowing that I was there, and I had seen these objects out of an exhibit, such as a loose compression hose at a construction site, I would not take much notice of them."—Jason Orban, junior history major

"The artworks featured in the Zimoun exhibit transform ordinary household objects with industrial materials to create a symphony of auditory art and movement. By transferring

these unconventional art materials and audio into an art setting/gallery, he . . . reminds the viewer of the power the artist holds; the artist is capable of transforming our perceptions of regular, everyday objects. He shows how aesthetically pleasing things can be if we look beyond their literal meanings/uses."—Clara Yan, freshman English major

"Although the material is common, the composition of it makes it unique. The pieces are all visually capturing and stimulating to look at. Interestingly, since the generated movement is never the same, one is never looking at the same picture. . . . There is a modern design element to all of the pieces and the 'less is more' expression is highly applicable here. The pieces have a modern, simplistic and elegant style, and the use of contrast appears often. The artist creates a situation and then lets it work for itself. A 'performance' is prepared for an audience, and once that performance is created it runs on autopilot."—Charlot Daysh, senior journalism major and exchange student from Norway

———◆———

As you can see, these students began with close observation and then drew conclusions about the messages that the artworks contained for them.

In its most broad definition, **art** refers to any expression of human creativity and imagination that is appreciated for its resultant qualities—whether that be sublime (like Renaissance art) or grotesque, and regardless of what emotions it may evoke.

Sometimes there is disagreement about whether or not something should be labeled "art." At times, this difference of opinion about whether or not something evokes an aesthetic experience has led to censorship, particularly if the content or composition of the work is perceived as risqué and/or sacrilegious.

For examples of controversial art, look up "Piss Christ" by Andres Serrano, "My Bed" by Tracey Emins, "The Holy Virgin Mary" by Chris Ofili, or another example of your choosing:

Describe the work:

What were the objections to the work being described as art?

Do you think it should be considered art or not?

What determines which pieces of art end up critically acclaimed, well-known, and influential is a complex equation. We must consider cultural and historical factors, as well as the execution of a piece. There are trends in aesthetics of art just as there are in fashion. As previously mentioned, classical art forms (across genres, including sculpture, theatre, and architecture) valued symmetry and beauty. Modern art can challenge this aesthetic by choosing the ugly and the off-balance as its subject and composition. Some pieces feel

"dated" after a while, while others retain a timeless quality to them. And, simply put, not everyone likes the same thing.

The identity of the artist can also be a factor. If you were asked to name a playwright from Elizabethan England, there would probably be one name that came to mind: William Shakespeare. But Shakespeare was only one of many playwrights writing during this time, and even though his reputation has outlasted all others, he was actually not the most popular playwright during his lifetime. That honor belonged to Christopher Marlowe, a quick-witted, college-educated, talented writer who died violently in his twenties. Nowadays, Shakespeare has become a recognizable "brand"—if an artist becomes well-known enough, it is possible for the merits of his or her work to be judged through reputation rather than critical analysis.

Theatre is an art that engages with its audience through multiple senses, and, like many types of art today, the body of theatrical works is a complex landscape of a plurality of aesthetics. There are trends we can identify, but no homogony. So, how will we begin to look at the art form of theatre and think critically about its messages?

WHAT IS THEATRE?

If a painting is made up of paint on canvas put into an intentional arrangement by an artist, what media are used to create theatre?

Use the following chart to compare different forms of art. What critical attributes do they share? Where do they differ?

	sculpture	dance	photo-graphy	music	short stories	poetry	theatre
Media used							
Audience relation-ship							
Other attributes							

Theatre is an art form that takes place in time and space. Theatre theorist Jerzy Grotowski boiled the art form down to a simple equation of essence:

Actor + Audience = Theatre

It is important to note that the audience must be present in order for the art form of theatre to exist. In this manner, audience members are not merely watching a play—they are experiencing it and they are part of it.

THEATRE VS. FILM AND THE MOVIE IN OUR MINDS

It can be a challenge to many of us to read a script and imagine something theatrical in our minds. Most of us, because of the prevalence of film and television in our lives, have developed a cinematic imagination. When we hear or read a story, we see a "movie in our minds." One of the goals of this course of study is to help you develop your theatrical imagination.

Film and television emerged as art forms much later than theatre, because the former are dependent upon different technologies. Consider that for many years of human history there was no such thing as photography. The closest humankind could get to visual representation would be a painting. Theatre evolved as a way for society to take a look at itself, and since the modern era, theatre has moved in two divergent and complementary directions: one towards greater accuracy in the representation of life on stage, and the other aimed at incorporating more overtly theatrical elements in order to present truth that is deeper than literal.

Look up and fill in the dates of the following inventions. How did these inventions change the way humans interact?

Photograph -

Telegraph -

Silent Film -

Microphone -

Computer-

Internet -

Digital Film -

Animation -

There were critics who became very concerned about the future of theatre when film became a popular art form, but time has revealed that there is a place in the world for both art forms. There are things that can happen on film that cannot happen in a live performance, but there are just as many things that can happen on a stage that cannot happen in a recorded medium.

Consider this comparative chart and see if you can add to it:

FILM	THEATRE
The camera directs our attention to what matters most in the storytelling through angles, close ups, and cuts.	The stage is a fixed performance space—whatever we are to notice must move into that space, where we are free to direct our attention to whichever performer or object catches our attention.
Scenes often take place in literal locations, or on sets that are created with full attention to detail.	All that is needed on stage to change location is for an actor to announce where he or she is. Sometimes sets can be quite literal, or they can be suggestive (i.e., a desk and chair represents an office).
"Type-casting" or literal casting is employed.	Casting is more flexible.
Once completed, a film does not change from one viewing to the next. One version is copied and distributed.	Each performance is different.
Editing is employed, often the film is not recorded in sequence and scenes are played over and over and only the best version will make it into the film.	No editing is possible—actors must take character's journey step by step from beginning to end with each performance.

THE EMPTY STAGE

Let us more closely examine the engagement that theatre asks of us as audience members.

The Relationship between the Audience and the Play

Theatre is a **collaborative** art, and very often it is a **collective** experience for its audience. For example, you may laugh at a line you hear or an image you see and cause someone else on the verge of laughter to explode as well. Or during a moment of high tension, you

Left image © Ollyy/Shutterstock.com; Right image © Kohlhuber Media Art/Shutterstock.com

How are the two aesthetic experiences represented above different?

may feel the power of a large group of people falling silent and focusing on exactly what you yourself are focusing on. Or, you may even grasp the hand of your friend in excitement or suspense, or make eye contact with someone across the room who is asking you with her eyes, "Can you believe what we just saw?"

In theatre, the relationship between the audience and the play is one that is constantly evolving as the play unfolds in performance. A common relationship between a performance and the audience involves the concept of the "fourth wall."

"The Fourth Wall"

A Frenchman by the name of Denis Diderot who lived in the eighteenth century is credited with the concept of the fourth wall. He said:

———◆———

"When you write or act, think no more of the audience than if it had never existed. Imagine a huge wall across the front of the stage, separating you from the audience, and behave exactly as if the curtain had never risen."

About the speaker:

In your own words:

This relationship dictates audience etiquette. This idea became especially popular with the rise of a style of theatre called Realism in the late eighteenth century, which attempted to show social issues on stage in a way that seemed plausible and true to life. When observing the fourth wall, the people onstage—actors playing characters—do not acknowledge the audience in any overt way. While they may speak loud enough to be heard all the way in the back of the room, or turn their bodies outwards to show more of their facial expressions to the audience, or pause to let laughter die down before delivering their next lines, the characters they embody are in essence ignoring the large body of people staring at them. A performance that observes this invisible barrier has a specific effect on our experience—usually that the audience is the outsider, looking in on events in a voyeuristic fashion.

Doing anything to call attention to oneself while the actors are trying to observe the fourth wall can be distracting both to the performer and to other audience members, and violates the unspoken contract between the audience and the actor.

Cell phones and "digital dependency" seem to pose particular challenges to this convention. Here are a few recent incidents reported through the media:

- In June 2014, a revival of *Cat on a Hot Tin Roof* in Los Angeles was canceled after an actor halted a performance to confront a drunken heckler.

- In 2009, Hugh Jackman stopped a performance of *A Steady Rain* in response to a ringing cell phone: "Do you want to get that?" he said, and continued to urge the cell phone owner to turn off the phone as its ring persisted.

- Broadway star Patti Lupone is well known for her intolerance of audience members taking illegal photographs during shows (and she has a point—you cannot take a picture of an actor without permission). There are several instances where she has stopped—even mid-song in a performance of *Gypsy*—to prevent the photos being taken and demanded that offending audience members be removed from the theatre.

But this relationship, though part of most conventional theater, is only one possible relationship an audience can have to a play. There are also performances in which audience members are expected to participate vocally, where they are encouraged to move around the performance space instead of sitting down, and even where cell phone use is welcome.

In fact, during Shakespeare's time, heckling from audience members was common, as were vendors selling food and other things in the seats (like at a ball game today). Actors delivered most of their lines in a declamatory style—not to their fellow actors, but directly to the audience. Sometimes they would deliver long, uninterrupted speeches or brief confessional lines about the characters' true motivation or feelings, not to any other person on stage, but to those watching.

Theatre artists can also choose to change the relationship with the audience at any given time through manipulating this concept. For example, how would your relationship to a play change if, in one scene, a priest delivering his sermon addressed you as a member of his congregation, and in the next scene you were looking in on a private meeting in a principal's office of a parochial school? *Doubt,* a play by John Patrick Shanley, creates just such juxtaposition for the audience. (We will examine this play as a case study in Chapter 2.)

SUGGESTED ACTIVITIES

- Write a journal entry in which you share a time when you have had an aesthetic experience with art of any genre.

- Compare and contrast a scene on film to the same scene in a recording of a stage version. (A good one to try might be the famous balcony scene from *Romeo and Juliet* by William Shakespeare.) What similarities and differences do you notice with regards to the storytelling? How does the difference inform your opinion of the characters or understanding of what is happening?

- Go to an art gallery and spend some time experiencing the art there (ideally, find some art that engages with more than one of your senses). Allow yourself time to look and listen carefully, noticing details, patterns, composition, etc. After viewing the installation, answer the following:

 1. Describe each artwork in the exhibit. What do they have in common? What makes each unique? How does the artist use his or her medium/media to create? (Research on the artist and/or genre would be helpful in providing a comprehensive answer for this question.)

 2. How would you describe your relationship to these pieces in terms of being an audience to them? Is there a "fourth wall"? Is there anything performative or theatrical about the pieces?

 3. If you could meet the artist, what two questions would you ask? What is your intention in asking these questions?

Theatre and Storytelling

> *"In theatre we construct journeys for audiences utilizing the tools of time and space. We create societies, tell stories and propose means by which people can live together with increased humanity, empathy, and humor. An effective production communicates in ways that infiltrate the audience in multiple layers, weaving details and scenes, narration, imagery, symbolic action, plot, and character."*
>
> —Anne Bogart from *What's The Story, Essays About Art, Theater and Storytelling*

About the speaker:

In your own words:

NARRATIVE

Storytelling is universal to the human experience, and it has been an essential part of theatre making throughout its history. But there are many different ways to tell the same story. Consider the fact that our lives actually have no story to them at all—they are a series of events that are shaped into story by our memories. **Narrative** is the structure imposed upon these experiences to create meaning.

© Everett Collection/Shutterstock.com

In theatre, narrative can be the backbone to a performance. The play begins by establishing the characters and their circumstances, then a main character, or characters, struggles to accomplish an important goal, and finally we find out if he or she succeeds or fails.

The most common storytelling structure is a linear cause and effect—one event leads to the next, which causes the next, and so on. Think about your first day in college. How would you tell that story?

What was your first day of college like?

Usually, we would tell the story in chronological order: "First I did this, then I did this . . ." Chances are, in telling the story you also omitted some moments—otherwise the story would have taken as long as the day itself! You probably also assigned meaning to certain events—whether consciously or unconsciously. For example,

if in your first class no one spoke to you and you spoke to no one, you might decide that was a clear indication that: (a) everyone at the university was unfriendly; (b) everyone was as nervous as you were; or even (c) people aren't supposed to talk to each other in college classes unless it is during a moderated discussion. In choosing what was important to tell and what wasn't, and in creating meaning from those experiences, you are giving a narrative structure to the events of your first day.

Two eyewitnesses to the same event will not tell the same story—each has his own point of view and that determines what they see and what details they deem important. And, strangely enough, science shows us that each time we share one of our own experiences, we overwrite our old memories, enabling our own stories to change over time. Perhaps you can recall listening to your grandmother or another storyteller recount a story you thought you had heard before and just before you tune out you hear a detail that you never heard before and your interest is piqued. That new detail might become part of the telling from now on.

But some stories are more interesting than others. What usually captures our attention when listening to stories is vivid language or imagery and how difficult things seem to be for the person or persons at the center of the story.

> What are the qualities of a good story?

CONFLICT

Perhaps you have seen live theatre before or a fight sequence in a movie (or even in wrestling entertainment such as featured by WWE). It is engaging to watch two (or more) characters "duke it out." Many stage plays depict fighting, whether physical or otherwise.

> Why are depictions of fights, whether a "shouting match" or physical violence, a common occurrence in stage plays?

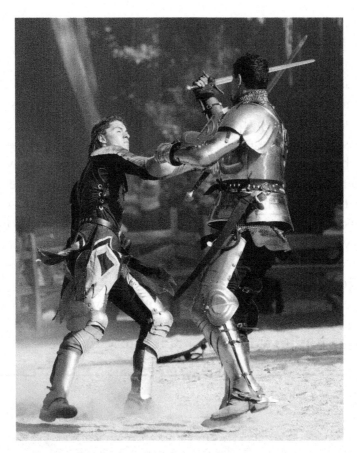

Knights "dueling" at the popular Renaissance Festival in Atlanta, 2010.

© Rob Hainer/Shutterstock.com

Stony Brook University students Aaron Ryan and Juan Pablo (JP) Cordon in *The Antigone Project*, 2014.

Courtesy of Jeanette Oi-Suk Yew.

Stage combat is a carefully **choreographed** and rehearsed movement sequence in which the actors involved are collaborating closely. The *characters* look like they are going to kill each other, but the *actors* are actually in total agreement about the choreography of what they are doing.

Conflict in plays encompasses more than physical confrontation—it can also be carried out in words and in other non-violent action. Since in life violence is often a desperate "last resort" tactic and the same is true in many plays (exceptions to this would be if the play is set in a world in which people tend to be volatile). Think about what possible progression of strategies one might use in order to avoid someone who persistently makes unwelcome advances at a party. Would your first choice be to throw a punch? Probably not. You could try to divert the conversation or the person's attention to something else, retreat to the bathroom with a friend, even spill a drink and avoid a direct confrontation. Even if things start to get heated, chances are they start with a "thanks but no thanks" and progress to a clear "no!" In a narrative-driven play you can expect characters to also follow a progression of tactics influenced by their personality traits and the gravity of the situations in which they find themselves.

Without conflict, narrative-driven theatre tends to get . . . well, boring. It is conflict between characters and between forces within characters that drives the narrative.

Here is a playwriting exercise from the Young Playwrights Inc. Write A Play! Curriculum that illustrates the importance of conflict in creating engaging theater.

The Dollar Bill Exercise

- Have two volunteers from class get up to do an improvisation. The first time through, one person drops a dollar bill on the floor and the other picks it up and returns it.

- Okay, so what happened? Someone lost a dollar and someone else was nice about it and gave it back. But aside from being able to label the person who returned the dollar as honest, or a "good Samaritan," we know very little about these people, nor do we care to know about them.

- Could it be more interesting to have the person who sees the dollar bill on the floor try to keep it? Have the volunteers try out this modified scenario and see if that is any more interesting. It should be, just a little bit. But it could be even *more* interesting.

- What could make this dollar bill very important to the person who lost it? What about to the person who found it? What does each person stand to lose or gain by getting or not getting this dollar bill? What is each person willing to do to get that dollar?

- Perhaps what is at stake for the people in the improvisation is connected to where they are. Where could they be that would make this conflict much more immediate?

- Or what if they have a specific relationship? Do they know each other or are they strangers?

- Or what if it isn't a dollar bill but a $20 or a $100 dollar bill?

- See what the volunteers can come up with and what the class as a whole can contribute. Chances are what you end up with is a very compelling story.

If you do this exercise in class, use the space below to brainstorm ideas about how to make the story more interesting by raising the stakes:

What choices from the exercise worked well in making what was at risk engaging to the audience?

This exercise focuses on one type of conflict in a play: conflict that exists between two characters, or **external conflict**. There is also the potential for conflict that exists *within* a single character. This **internal conflict** can also up the stakes in dramatic storytelling. Most great plays include a combination of both. Any time a play puts an obstacle in a character's way that makes it more difficult for that character to accomplish his or her goal we have conflict—and a pretty good story.

PLOT

Think about the distinction between what is shown on stage in a play and what occurs offstage. The events that are portrayed—the moments that form the "stops" along the journey of the narrative—comprise the **plot** of the play. There may be other events that are recounted by messengers or implied indirectly, but these events are part of the story, not part of the plot, since we don't see them unfold onstage.

As previously discussed in this chapter, the impulse for storytelling is a universal one. Several cultures have independently developed theatre as a way to tell stories. Generally, our American theatre landscape owes most of its heritage to Western theatre practices that began in ancient Greece and evolved throughout Europe over hundreds of years. Without influence from this Western origin of theatre, countries in the East and in Africa also developed theatre. These independently developed theatrical forms have their own performance vocabularies and aesthetics for storytelling.

A conventional plot—one that the Greek philosopher and educator Aristotle, one of the first theatre critics, would have approved—is one in which we first encounter and get to know the characters shortly before the climax of the play. The scenes, therefore, take place chronologically and without much time passing between them. In the play *Oedipus* by Sophocles, we first meet King Oedipus in the middle of the night as he greets the

citizens of Thebes to reassure them that he is taking action to improve conditions in the city. We then follow him throughout the day as he takes on the goal of saving the people from suffering by expelling an unidentified murderer from their midst. Before the end of the day, Oedipus discovers that (spoiler alert!) he is the murderer he seeks and takes action to punish himself for his deeds.

Many plays follow this tightly constructed plot pattern. They also usually focus on only one thread of narrative (without any side or sub-plots) and are likely to also take place in a single location.

Other plays follow a chronological order, but may span years, sometimes even decades. This means that there is more time that supposedly elapses between the scenes, and there will be changes indicated to have happened over time in each isolated "episode."

Of course, there is nothing that says the plot of a play has to adhere to chronological order. Scenes can take place as "flashbacks," or time can move in reverse. All the audience needs are some clear "road signs" to follow along. *How I Learned to Drive* by Paula Vogel uses literal road signs and a main character who narrates her journey to take the audience along as she remembers and reframes an intimate relationship she had with a family member.

> Go back to your story about your first day of college. How else could you organize the plot? Use the space below to re-write your story using a non-linear structure:

Other ways to organize a plot include thematic connections, or multiple perspectives on a single event, such as in Anna Deveare Smith's *Fires in the Mirror*. This is a solo show in which she embodies people she interviewed about the Crown Heights, Brooklyn Riots which occurred in 1991 and performs their words verbatim. However, it is edited together in an intentional way as to gradually illuminate the complex multiple viewpoints on those violent and racially motivated events.

Writer and Performer Anna Deveare Smith
© *Everett Collection/Shutterstock.com*

CASE STUDY:
Doubt by John Patrick Shanley

Getting Ready to Read a Play

During this course you will have the opportunity to read play scripts. This is in many ways analogous to looking at a blueprint when you want to be talking about a house. A script is a plan for a production, and it is in fact not complete without a creative team to bring the play off the page and perform it. That doesn't mean that reading a script is devoid of enjoyment, nor that it lacks benefit in theatre studies.

One advantage to reading a script is that you control the pace. You can go back and re-read passages or whole scenes if you wish. You also have access to something audiences never get to see in a production: **stage directions**. Play scripts consist of two types of text: the words the characters say, or **dialogue**; and everything else, otherwise known as stage directions. Stage directions can include important movements of the actors, instructions to the actor on how to deliver a line, sound effects, lighting effects, descriptions of sets and props, and whatever else the playwright can imagine. Looking carefully at the stage directions in a play can provide a lot of insight about how that play might look on stage. (We will look more closely at stage directions in Chapter 3.) Some scripts also include a preface or notes from the playwright that can communicate quite a bit about his or her inspiration and intention in writing the play, including details about process and production history.

In the previous chapter, we talked about our cinematic imaginations and the tendency for our minds to construct the stories we read as if they are occurring in a movie. This is one challenge to reading a play script. As you read this example play, try to imagine how it might look on a *stage*. Where would the scene take place in the performance space? What furniture and props are necessary? What would the actors be wearing? How would they move and talk? Try to see if you can hold that visual in your mind as you read. For performances, body language is usually more significant than the spoken language used.

Another aspect of reading plays that you should keep in mind is that it is only natural that we get drawn into the story as it unfolds. If we become too engrossed in the narrative, we will cease to ask questions of the text as we read, and therefore we may miss important insights. If you find yourself taken in by the story in this play, enjoy it! Then, go back and re-read places where you were not aware of structure or of the text as a blueprint for performance. Here are some questions to guide you as you read:

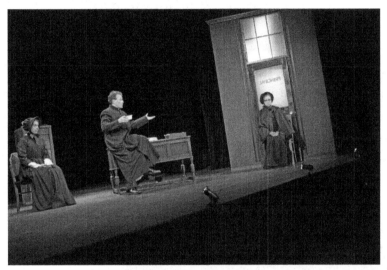

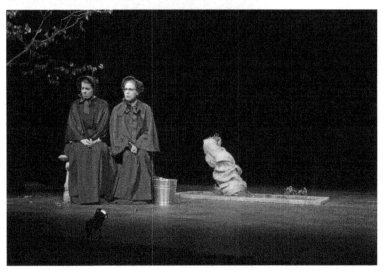

Doubt, written by John Patrick Shanley, produced by Asylum Theatre Company, 2014. Photos printed by permission of Asylum Theatre company. Photos taken by Andrew Breslin. Actors pictured: Steven Lantz-Gefroh as Father Flynn, Valeri Lantz-Gefroh as Sister Aloysius, and Nancee Moes as Sister James.

CRITICAL QUESTIONS

1. How would you describe the structure of this play? What kind of speech do the characters use? How is the story told?

2. How much time passes over the course of the entire play? In between scenes?

3. What kind of relationship to the audience exists for each scene?

4. How do you picture the stage being set up for this play?

5. Several scenes begin with a stage direction that includes "crossfade." How does that description influence what you see in your mind's eye happening on stage?

6. How do you know it is 1964 OTHER than from the stage directions?

7. When do we learn that Donald Muller is a "Negro"? How does this knowledge change our understanding of the story?

8. What is the conflict of this play?

9. What evidence (circumstantial or otherwise) is presented to bolster Sister Aloysius's accusations?

10. What evidence (circumstantial or otherwise) is presented to bolster Father Flynn's innocence?

Here is a map of the structure of the play for you to fill in as you discuss it:

Scene	Location	Description
1		
2	Aloysius's office	
3		
4	Garden	
5	Aloysius' office	
6		
7	Garden	
8	Aloysius' office	
9	Garden	

SKILLS FOCUS:
Creating Effective Interview Questions

Questioning is an analytical skill essential to the process of theatre. One can ask questions of a script (as illustrated in the case study on *Doubt*), or of a performance, as well as of a person. For this skills focus, we will concentrate on interviewing artists.

Effective interview questions are specific, polished, varied, and invested.

Specificity

When interviewing artists about their work, it is important to be specific in your questioning. A general question will usually yield a general answer. The more tailored towards the artists, the more they know you have invested in hearing from them specifically. In order to do this, you must know something about the artists' background and body of work.

Polish

Being concise and efficient with your questioning will also yield better quality answers from your interview subject. You want to hear what they have to say, not the other way around. If you are submitting your questions in writing, take the time to polish your phrasing and this will pay off in the response.

Variation

When asking more than one question of an artist, make sure you are asking about different aspects of his or her work. Address the breadth of the artist's experience—not just one project (unless the interview is specifically about one project). The answers you get will tell a more complete story of the artist's work.

Investment

Building on what you know from your research and have observed from interacting with work by the artist, you should be able to demonstrate why you want to know the answer to the questions you pose. Perhaps you have a personal investment or connection to a message or a quality in the work, or perhaps you have conflicting ideas that you want resolved. Whatever the reason, the more investment you are able to demonstrate, the more you will motivate your interview subject to provide you with thoughtful, comprehensive answers.

In light of these guidelines, look at the following questions and see if you can determine which ones are more effective than the others. (These questions would be directed toward an artist who has a background and interest in engaging with ethical issues surrounding gender, which has been demonstrated most recently in a multimedia performance in which she was the solo actor.)

- **What inspires you?**

- **Have you ever been injured on stage or on the set?**

- **What's the best part about being an actor?**

- **You have degrees in both gender studies and dramaturgy. Was it always your intention to combine the two in your work?**

Let's look at each of these a little more closely.

- **"What inspires you?"**—This question could be asked of any artist, nay, probably any human being. It lacks specificity, and therefore it may be a difficult question for an interviewee to answer.

- **"Have you ever been injured on stage or on the set?"**—This question is a bit out of left field, and it isn't likely to be grounded in any specific knowledge about the artist being interviewed.

- "What's the coolest part about being an actor?"—Okay, so this question is specific to an actor, but the phrasing needs some work. First of all, does anyone use the word "cool" anymore? It makes the interviewer sound somewhat juvenile at best and disrespectful at worst.

- "You have degrees in both gender studies and dramaturgy. Was it always your intention to combine the two in your work?"—This is the one that is the strongest in the bunch. It also is the only one that provides an introductory statement that leads into the question. The first sentence here lets the artist know that the interviewer has done his or her homework and wants to know about that artist specifically.

In terms of demonstrating investment as well, the complete question might read:

> "I was reading your bio in the program and noticed that you have degrees in both gender studies and dramaturgy. I am a double major myself and am always curious about how people prepare themselves for unique paths through attaining training in different fields. Was it always your intention to combine the two in your work?"

This is a complete question that uses all four guidelines effectively.

During the course of the semester you will hopefully have several opportunities to talk to artists about their work. Keep in mind that good questions come from a place of specific knowledge, they are carefully constructed, they focus on different points of engagement with the artist's work and/or process, and they demonstrate why it is important to you to learn the answer.

As we progress through this book and course of study, you will read several printed interviews with theatre artists. Opportunities may also arise for you to meet theatre artists in person. Keep practicing how to ask effective questions, and you may see improvement in your critical analysis stills as well.

SUGGESTED ACTIVITIES

1. Object skits: Select an object from your life that has special significance to you and has a story associated with it.

 - How can you relay the significance of this object in a vivid and engaging way? Write that story on paper.

 - If possible, bring your object into class.

 - Then share your story with a group of your classmates and see if you can use the object and your bodies—*without* using words—to tell the same story to the rest of the class.

 - Perform these short skits for the rest of the class. What story did they construct from your silent scenes? When was the communication clear and when was it perhaps less so?

- What did the restriction of not being able to use spoken language do to your story-telling choices?

2. Write interview questions for an artist you will meet or would like to meet.

RECOMMENDED READING

- Bogart, Anne. *What's the Story: Essays About Art, Theater and Storytelling.* Routledge Press, 2014.

- Shanley, John Patrick. *Doubt.* Dramatists Play Service Inc. 2005.

- You may also want to check out a great blog by playwright Adam Szymkowicz, called "I Interview Playwrights." He's up to almost 900 interviews and counting!

 http://aszym.blogspot.com/

The Theatrical Environment

66 *The stage is a concrete physical place which asks to be filled, and to be given its own concrete language to speak. I say that this concrete language, intended for the senses and independent of speech, has first to satisfy the senses, that there is a poetry of the senses as there is a poetry of language, and that this concrete physical language to which I refer is truly theatrical only to the degree that the thoughts it expresses are beyond the reach of the spoken language.* 99

—Antonin Artaud from *The Theater And Its Double,* 1958

About the speaker:

In your own words:

66 *A stage setting is not a background; it is an environment.* 99

—Robert Edmond Jones from *The Dramatic Imagination,* 1941

About the speaker:

In your own words:

***Elegy For a Vacant Lot* (2009). Conceived and Directed by Judith M. Smith.**
Photo by John Hagan

In Chapter 1, we established that:

Actor + Audience = Theatre

And in Chapter 2, we explored storytelling through text and physical actions. In this chapter we will look at storytelling through environment.

To begin, think about your journey to this class today in terms of sensory description. Think of images and label them with adjectives, recalling as much sensory information as possible, such as whether the air felt "cold" or "warm"; whether the texture of the ground that you walked on felt "hard" or "soft." Consider questions such as: Where was the light harsh or soft? How did the air smell to you? How did the people smell to you? What were the senses that stood out the most to you? As you are recalling the journey, begin to jot down the adjectives, sequentially to the steps you took that encapsulate your feelings and experience.

Now let us go backwards. For every adjective you have listed go ahead and find the *antonym* (the opposite meaning) without changing the sequence of the steps in your journey. For example, if the air outside felt cool to you before, it would be warm.

Adjectives describing your journey to class	antonyms

How does this new list of adjectives change the environment of your journey?

What are the new images you conjure?

How do your feelings or experience of the journey change?

It is important to note that in this exercise many of the environmental elements are uncontrollable, such as the weather or the traffic you encountered on the road. However in a theatrical environment, we aim to identify and organize as many controllable elements as possible. In this chapter we will explore these elements and how they connect with the aesthetic experience, particularly focusing on how you, as the audience, experience a piece of theater.

THEATRICAL ENVIRONMENT

When we think of seeing theatre, the first image that probably comes to mind is a stage where the play unfolds and we are sitting opposite to it, watching. Something like the image below:

However, the physical stage where the play unfolds is not the same as the theatrical environment. If the stage is the canvas, then the theatrical environment is the painting created in that

© Pavel L Photo and Video/Shutterstock.com

space. An environment consists of a set of **design elements**, such as **sets** (or scenery), **costumes**, **lights**, **video**, **props** (short for properties; small handheld items that are used on stage to enhance storytelling); and **sound and/or music** that make up the sensory **WORLD** for a play to inhabit. It sets the conditions that dictate how the audience encounters and interacts with the play, i.e., the audience relationship.

For example, when a character "breaks the fourth wall" by crossing from the stage to the audience area, the previously assumed relationship in which the audience is strictly an observer will shift to a relationship in which the audience is more actively involved. With

this shift, the world of the play has expanded from a controlled sensory environment to a less controlled one. If the character then walks out of the theater and onto the street, it will shift further to include the city. Sometimes this shift is not apparent until a certain moment in the play while at other times the entire environment reveals itself from the start. Either way the production team *intentionally* conceives and designs it.

The goal of this world is to transform the play text into a sensory experience. It is very important to understand that there is no standard world for any play even if the particular play has been produced many times. The world is designed specifically for this particular performance to exist at this particular time for this particular audience. Therefore NO two productions will be the same. The specific world supports the particular concept of the production and it is all encompassing in terms of style, period or era, status, and social norms or social issues. It stimulates all of the senses and contributes to atmosphere and mood.

For example, imagine yourself at a department store that sells furniture. At one side of the store is a couple that begins to argue passionately about which fabric color is appropriate for their sofa. The argument becomes very heated to the point that the entire store begins watching this exchange. If you took a moment to look around, you would see that each member of the "audience" would have a different physical relationship to the action, and their understanding of the actions would also vary depending on when they focused their attention on the event. As an audience member, you also experienced how the atmosphere of the store shifted and became tense within the seconds it took for the entire store to watch this exchange. If this were an actual theatrical piece, it would have successfully created a world for this argument to unfold in and provoked a set of feelings from the audience.

The Relationship of an Audience to the Action

As mentioned before, when we think about going to see theatre, we generally envision a stage in front of us with the audience all sitting on one side. This setup is called the **proscenium**.

Draw a representation of a proscenium setup in the space below:

It is the most common and familiar audience relationship. The audience views the play through a "frame" in which the action of the play takes place. There is often an arch built around the edge of the stage that literalizes this "frame" concept.

This configuration allows for set pieces and actors to be concealed from the audience before moving into the visible playing area. This idea developed during the Italian Renaissance (primarily in the fifteenth century) when controlling how the audience viewed the stage picture was an important goal because of perspective drawings and the need to create stage illusions. There was also a boom in the construction of theaters at this time that continued into the late 1800s, and many of them are still functioning as theater spaces today (some were converted to movie theaters and then converted back). This "frame" idea is connected to the concept of the "fourth wall" as described in Chapter 1, and creates a similar relationship to that of watching television and film. The seating in a proscenium set-up is arranged to try and give each person in the audience a similar, unobstructed view of the action on stage.

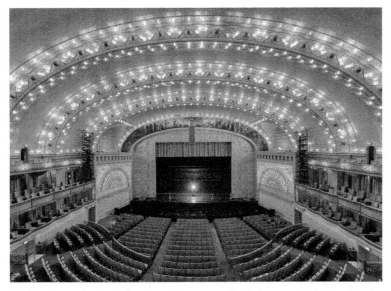

Empty Auditorium Theatre of Roosevelt University on October 14, 2012 in Chicago, Illinois. A proscenium setup.
© Nagel Photography/Shutterstock.com

However, this is not the only way to configure theatrical space. Have you ever stopped to watch a street performance? If you did, you might recall that the audience in those settings is standing around the action, encircling it. This configuration is the most comfortable and natural to our instinct and in theater it is called an **arena** (yes, like a boxing arena) or sometimes "theatre in the round." In this case, the audience is on all sides of the stage. In this setup, unlike the proscenium, the audience is aware of its own presence since you can see each other while watching the action.

Draw a representation of an arena setup in the space below:

So far we have discussed two completely opposite setups: proscenium and arena. However, there are variations in between these setups by modifying or combining them. Each seeks to establish a different relationship with audience. For example, it is estimated that there were 150,000 people attending any given theatre performance at the height of the Classical Athenian during the origin of Western theatre traditions. The Greek stage consisted of an orchestra area that is a circular performance area (see the image below). Although the performance area is circular, the audience (the stone steps) did not wrap around the playing area completely; the upper portion of the performance area almost functioned like a proscenium stage.

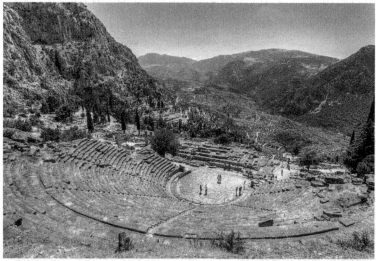

© Anastasios71/Shutterstock.com

After the fall of ancient Greece, this configuration slowly evolved into the proscenium. However, it made an appearance in Elizabethan England during Shakespeare's time—and The Globe Theatre is the most famous example of it. It had two major audience areas. The one immediately in front of the stage was the yard for anyone who could only pay a penny and the sides were galleries for high-class patrons. As previously mentioned, during Shakespeare's time the relationship between audience and the performances was very interactive. A lot of this had to do with the arrangement of the patrons in relation to the action on stage.

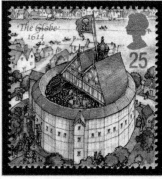 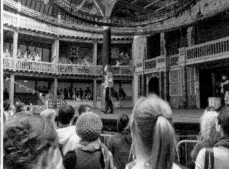

© Galyamin Sergej/Shutterstock.com © Padmayogini/Shutterstock.com © Kamira/Shutterstock.com

Images of the Globe Theatre and its existing reconstruction.

Eventually, in modern times, this configuration became a **thrust** stage, with the audience on three sides of the playing area. It creates multiple vantage points and some similar effects as an arena for some members.

Draw a representation of a thrust setup in the space below:

With the rise of experimental theatres in the late 1800s came an interest in exploring how different types of space configurations could redefine the relationship between audience and the action. This drive, combined with economics, gave rise to the **black box** theater, which is often a flexible space that can be configured as a proscenium, thrust, or arena, or with no fixed seating at all.

If there is no fixed seating at all, one possible relationship is to create an **immersive** configuration, in which the audience is mixed among the action. In an immersive theatre set-up, the audience must pick a vantage point from which to view the performance. The furniture store example from earlier in the chapter is an example of immersive theatre. One of the most famous examples from contemporary theatre would be Punkdrunk Theatre Company's *Sleep No More*.

Sleep No More is an adaptation of Shakespeare's *Macbeth*. Except for the title, most of the original text is eliminated. In its place is a highly artistic world created by converting a five-story warehouse in Chelsea, New York City, into a fictional location called The McKittrick Hotel. This fictional location is the overall environment. Within it there are many mini-environments, including a graveyard, a hotel lobby, a ballroom that also doubles as a forest, a hospital, a lounge inhabited by fortune tellers, a main street with stores and offices, and many more. The narrative thread is communicated through a combination of choreographed dance movement, a layered soundscape with songs, dramatic lighting, and stage combat. Episodes of narrative actions between the characters of *Macbeth* erupt in different mini-environments throughout the three-hour long performance. In addition to not having fixed seating, the audience is encouraged to explore any environment (including eating the candy in the candy store) and to encounter and experience the narrative episodes. In the end, each audience member's experience is unique to what he or she chooses to do.

Occasionally the immersive experience is also "interactive theatre"—theatre in which the audience can directly influence the actors or affect the outcome of the action. Having the audience intermingled with the performers supports this kind of direct communication

and influence. However, not all immersive theatre includes audience interaction, and interaction may occur in any one of the other space configurations. For example, in Act Two of *Ludic Proxy,* a play written and directed by Aya Ogawa (2015), the audience was asked to vote within a set of given choices in order to advance the actions of the play on behalf of a character. The overall play was not an immersive experience; it was set up as an arena with fixed seating.

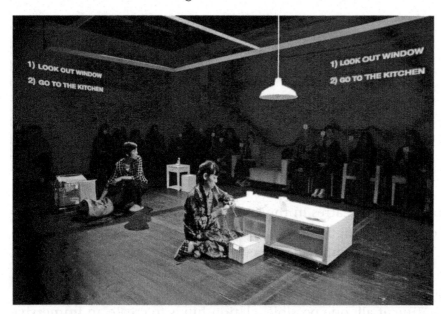

Ludic Proxy (2015).
Written and Directed
by Aya Ogawa.
© *Carol Rosegg*

All of the configurations we have explored thus far have occurred in designated theatre spaces, but theatre may occur anywhere. Theatre that takes place outside of the confines of a space dedicated for theatrical performance is called **site-specific** theatre. For site-specific productions, the audience-action relationship can be proscenium, thrust, arena, or immersive since the designation "site-specific" is related to the physical location where the performance is taking place. For example, a Catholic mass takes place in a church, which makes it a site-specific production (yes, a mass can be considered a form of theatre), but the audience to performer relationship is very clearly proscenium. Site-specific can also refer to performing a more traditional play in a space not usually designated for theatrical performance. For example, there was a production of Anton Chekhov's *The Seagull* performed in a house on Lake Lucille in Rockland County, New York. Since the setting of the play is written for a house, the house on Lake Lucille became the site and therefore the world for this particular production. Because non-designated theatre spaces might not have large rooms in which the audience can assemble as one group, site-specific theatre is more likely to have an immersive configuration, or some other flexible audience relationship to the play. Ideally, the site that is chosen should reflect and illuminate the ideas of the play, and not be chosen arbitrarily.

Theatrical Environment as World

The elements that go into creating a theatrical environment are divided among specific design areas. Designers are expert in their skill set, and they work together to create one cohesive world. The different design areas are:

- *Set Design:* responsible for designing the visual physical space from seating arrangement (if not given) to all the settings as indicated in the play. These settings can be manifested on a stage or not.

- *Costume Design:* responsible for designing what the characters would wear to highlight their character; both internal (psychological) and external.

- *Lighting Design:* responsible for designing an atmosphere that evokes a certain mood. Unlike set and costume, lighting does not have a physical aspect to it (except with a light bulb); hence it is more experiential.

- *Sound Design:* responsible for designing the audio environment. Like lighting, it also does not have a physical form and is more experiential. Sometimes the sound designer is also responsible for manipulating voice.

- *Video Design:* responsible for designing visual images that are digital. Sometimes it is used to affect moods through texture and abstract imagery while at other times it is used as a slideshow to provide information. This is a very new field that has a wide range of applications.

STAGE DIRECTIONS

As you noticed when you read *Doubt,* in most modern play scripts there are written directions called stage directions. They are usually set apart from the words the characters speak by parentheses and/or italics. The audience has no access to this writing when experiencing a performance and it will need to be presented

 a. As part of the visual environment
 b. Through actions, and/or
 c. Experientially through creating an atmosphere or establishing a mood.

Stage directions have many purposes:

1. **To provide background information** such as in Scene One of *Doubt:*

 "A priest, Father Flynn, in his late thirties, in green and gold vestment, gives a sermon. He is working class, from the Northeast."

2. **To provide information on the entrances and exits of characters.** You will find this is virtually the only instance of stage directions in many of Shakespeare's

plays because the original scripts did not have many stage directions at all, and subsequent productions have added the information for clarity.

3. **To suggest movements, actions, or pacing for the performers to bring into their acting choices.** Often this is where *subtext*, the intention or meaning *behind* the spoken text, is being developed. For example in Scene Two of *Doubt* when Sister Aloysius and Sister James discuss a student:

SISTER ALOYSIUS.	Good. That girl, Linda Conte, have you seated her away from the boys?
SISTER JAMES.	As far as space permits. It doesn't do much good.
SISTER ALOYSIUS.	Just get her through. Intact. *(Pause. Sister Aloysius is staring absently at Sister James. A silence falls.)*
SISTER JAMES.	So. Should I go? *(No answer.)* Is something the matter?

4. **To offer a description of the setting**, such as the opening of Henrik Ibsen's *An Enemy of the People:*

"DR. STOCKMANN'S sitting-room. It is evening. The room is plainly but neatly appointed and furnished. In the right-hand wall are two doors; the farther leads out to the hall, the nearer to the doctor's study. In the left-hand wall, opposite the door leading to the hall, is a door leading to the other rooms occupied by the family. In the middle of the same wall stands the stove, and, further forward, a couch with a looking-glass hanging over it and an oval table in front of it. On the table, a lighted lamp, with a lampshade. At the back of the room, an open door leads to the dining-room. BILLING is seen sitting at the dining table, on which a lamp is burning. He has a napkin tucked under his chin, and MRS. STOCKMANN is standing by the table handing him a large plate-full of roast beef. The other places at the table are empty, and the table somewhat in disorder, evidently a meal having recently been finished."

5. **To relay the mood and atmosphere** of a play. For example, August Wilson's *Joe Turner's Come and Gone* opens with:

"It is August in Pittsburgh, 1911. The sun falls out of heaven like a stone. The fires the steel mill rage with a combined sense of industry and progress. Barges loaded with coal and iron ore trudge up the river to the mill towns that dot the Monongahela and return with fresh, hard, gleaming steel. The city flexes its muscles. Men throw countless bridges across the rivers, lay roads and carve tunnels through the hills sprouting with houses."

You might think that this last example is the most challenging for designers because it does not give the designers any concrete information. However, it is a misconception that Number 4 is easy it because it describes the setting in such detail. It actually describes very little as to what we visualize, and in fact there is no information on the characters at all. Are they rich? Are they healthy? What does "plainly" mean? (No pattern? All beige furniture? Only straight lines?) Does the room have windows? Is the couch worn? Does

the room feel old or modern? Is it clean? How big is this room actually? (And what information about this household would it communicate if this room were a very spacious room versus a very cramped one?) What is the overall color palette of this room? How can you tell the audience that it is evening? Is Dr. Stockmann's home located in a city or a rural area? What does the room sound like? Does this room have a smell? All of these are questions designers ask when coming up with the world for this play.

Use the space below to draw a diagram of what the set might look like as described in the 4th example, the opening stage directions of Ibsen's *An Enemy of the People:*

REPRESENTATION AND IMAGINATION

When the photograph was commercially introduced in 1839, it was the first time the world saw how actual reality could be captured fully. Before this, all artworks that captured the world were done through an interpretative process (the hands) of the artist. Consider again that famous painting "The Mona Lisa" by Leonardo da Vinci that we mentioned when discussing art. Many scholars have studied it, and as of today there is no certainty as to who was the model in the portrait. It is most famous for, amongst many aspects, how the woman seems to be gazing at you no matter where you are standing when looking at the painting. If Da Vinci took a photograph instead, it would not generate the same debate.

The invention of photography coincided with the development of *Realism* and laid the foundation that theatrical designer Robert Edmond Jones argued in his 1941 book *The Dramatic Imagination:* "We all become fascinated by actuality. We want to see everything just as it is. . . . Scene-painting becomes realistic, action becomes casual, dialogue is modeled after the speech of everyday life."

What Robert Edmond Jones described in his writing is the problem of representation, or rather the problem of relying on *visual representation* as the primary framework for understanding a narrative. At the time he was working and writing in the first part of the twentieth century, there was concern amongst theatre makers about competing with the increasingly popular art forms of film and television for audience attendance. Some productions attempted to represent actuality as much as possible to the degree of having photographic images projected on stage, to structuring a script with rapidly changing

locations like in films. Oftentimes, audiences walked away from these productions feeling that the theatrical environment was mediocre because it did not create an *actual* restaurant (or any "real" location) on stage, just an imitation of it. Over time, audiences saw less and less of a difference between seeing theater and seeing a movie, and theater that tried to create "real" environments was usually viewed as less impressive.

The truth is, live theater is not a medium that can completely represent actuality, and the audience is intrinsically aware of that. What we do have is the ability to "suspend our disbelief": The adaptability of our brain allows us to move symbolically and abstractly to complete the picture for ourselves. Take lighting, for example. It is impossible to mimic a sunrise on stage because a sunrise is an outdoor phenomenon, and seeing theater is mostly an indoor phenomenon. In real life, we experience it through seeing the sky, and the time shift is illustrated by the changes in the brightness and color of the atmosphere. Hence if a scene asks for a sunrise, it is impossible to re-create it on stage. But what a designer *can* do is to evoke the *sense* of a sunrise and let the audience complete the picture.

A great example of how this can be done is in Julie Taymor's *The Lion King*. The opening number, "The Circle of Life," is designed to be magical, to evoke the vastness and beauty of the African plain and all the animals that inhabit the land. During the song, the sun is to rise and the animals are to emerge from the landscape. As you can imagine, this is a challenge no matter how big the theater might be. In the end, the team of theater designers along with Julie Taymor came up with a few very simple stage pictures and approaches that evoked this environment:

Describe how the sun was constructed:

How did they create the feeling of a wide-open African plain?

Where do the animals enter from? What is the effect?

What happens to the amount and color of lights on stage from the beginning of the song to the end?

What types of rhythms and instruments in the music contribute to setting?

What happens vocally in the song from beginning to end?

None of the elements are a direct representation of actual objects in our life, but the audience can imagine itself in the middle of the African plain at early sunrise seeing the animals waking up and activating the environment.

SUGGESTED ACTIVITY

Read the following opening stage directions from Samuel Beckett's 1953 play, *Waiting for Godot:*

> *A country road. A tree.*
> *Evening.*
> *Estragon, sitting on a low mound, is trying to take off his boot. He pulls at it with both*
> *hands, panting.*
> *He gives up, exhausted, rests, tries again.*
> *As before.*
> *Enter Vladimir.*

Come up with a world in which this play can take place. Use the following prompts to guide you:

- What can we see?

- What do Estragon and Vladimir look like?

- What does it sound like?

- What kind of tree is it?

- How can you tell the audience that it is evening?

- What kind of audience relationship would you have?

- Do not forget to consider the atmosphere and mood.

After you imagine, search through Google images or another search engine and discuss the different ways this world has been created. What do they all have in common? In what ways do they differ?

INTERVIEW:
Joe Silovsky, Set Designer & Performance Artist

What follows is the first in a series of interviews conducted by one of the writers of this textbook. The artists have been contacted specifically for the purpose of sharing their work with you, the student. This particular interview was conducted over email, and the questions have been shortened for clarity.

Courtesy of Joe Silovsky

"My medium is machines and robots. That's how I communicate."

Joe Silovsky is a set designer and an object-oriented performance artist from Oklahoma who moved to New York in 1999. He is the Technical Director and Performer for The Builders Association, a New York-based performance and media company, and he has built robots and other machines for Richard Maxwell, NYUSA, Radiohole, and Lucky Pierre. His work originates in non-fiction source materials, and within a context of a whimsical one-man show he uses technology, video environments, projection mapping and soundscapes to help tell a story. Calling himself "totally self-taught," Mr. Silovsky studied sculpture at Bard College and performance at the School of the Art Institute of Chicago.

What would you say your personal aesthetic is?

I could state that my aesthetic is a comedic, hacked, mechanical, coarse mixture of hi and low-fi technology applied to telling stories. That stems from my understanding of aesthetic as concerning beauty—what the audience experiences (visually, aurally, etc.)

that gives pleasure. But I can also look up other definitions of aesthetic—a set of principles underlying and guiding the work of a particular artist—and that brings up a larger discussion. The principles underlying the decisions that form the "beauty" of the work are complex and multileveled. My decision to work crudely, with simple cut out drawings as puppets or with machines constructed with no regard to visual aesthetics, only functionality, is both aesthetic and political.

Where do your creative impulses come from?

My impulses come from synchronic moments: from recognizing patterns in one aspect of research (or aesthetic play) reflecting in other aspects, be it historical reading, or mechanical experimentation, or improvisation in rehearsal; from noting how the mechanical motion of a sewing machine resembles the motion of wind-blown grass in a movie. Patterns across media emphasize their similarity and at the same time acknowledge their differences, and create an aesthetic tension that is pleasurable. It is this tension that I am after, that for me is the "creative impulse" that makes something worth pursuing.

Do you have a personal "mission" or sense of what type of work you want to put out into the world?

Yes. I want to put work out that is difficult, but pleasurable to experience; that forces the audience to be mentally active in their consumption of the material by challenging their understanding of the patterns that arise; and that is edifying about a specific historical event without lecturing or being bombastic.

I know we've spoken before about how important historical research is to your work, but I'm sure that other things contribute to the exploration of an idea as well.

I do tend to focus on an historical event as the core of a piece. But then I try my best to avoid the center; to research all around the core story, rather than have a singular focus. The marginalia is often ripe with strange quirky stories and points of view that actually enlighten the central story in unexpected ways, and provide new egresses into the core material. Aside from straight book-bound research, I am also always exploring technical and mechanical ideas, as well as writing and trying out short skits. The various threads often mature together and the sparks of sympathetic patterns begin to appear. For instance, this machine connects to that concept in one of the historical books, or some such.

In creating "theatrical environments," what are you going for? What type of experience are you looking to engage the audience into?

In my own work, I am partially making a Rube Goldberg environment, where there are a lot of strange objects on stage that pique the audience's curiosity and keep them engaged with wonder. With others' work, I try to incorporate those ideas, but I don't try to force my own aesthetic on someone else's piece. I actually try to be as minimal as possible—to make a set that allows the most important part of the show to shine. I use the set to frame whatever is important; if the piece is emphatically textual, then I try my best to support

and not distract from the words. There are often tricks and machines built into those sets as well, but the tricks are kept out of the audience's eyes. They are there to make transitions easier so they don't distract from the words.

How do you see the relation of design with performance? The items you have designed are very integral to the performance (i.e., they are not just "backdrop"). Can you share your thoughts on this topic?

For my own personal work there's no extricating design from performance; it's just all one and the same thing. It's hard to imagine trying to do one of my own pieces without the design and the concepts blending together—that's where I think it is strongest. But, when you're working with other folks' material and subject matter, it's harder—being in the real world you can't spend years trying to tweak out a specific mechanical design for a specific idea. It's integrated when you're working with others. I also think there's a difference between a personal aesthetic, in terms of your own work, and a design aesthetic that you use when working with others. Not everyone wants this kind of hackneyed mechanical aesthetic to their work that I like. I use my talents and skills to reinforce their story, but not particularly use that hackneyed aesthetic that's part of my own work.

I find that it's much better to work with the design through a longer process. At The Builder's Association, it was integral to their work process to have all the designers and all the performers there from the very beginning. As the whole piece progressed everything blended together, and the design wasn't just a 'backdrop' because it's integrated into the piece. You've spent the time together developing the ideas in tandem. It's rare that you can work like that, though. It's a pleasure when those opportunities arise.

You've accumulated quite a body of work over your career. Which of your pieces are you most proud of, and why?

Two works of mine particularly stand out as my favorites:

Send for the Million Men, because it has been a culmination of so many strings, both aesthetic and conceptual, that I have been working on for years. Atop of this culmination was the step into a more collaborative development of the final work, which was a risk since it was new territory. The collaboration fleshed out and improved the ideas in ways I did not expect and am now happy to understand.

The Reddest Dirt in Oklahoma, as it was the apex of a certain tangent of my own performance style—the opposite end of the spectrum from *Send for the Million Men.* I am the lone performer on stage struggling against a collection of props that keep failing. It was also the most personal, as it concerned the Oklahoma City Bombing that my mother survived.

How do you see the evolution of technology with storytelling on stage? For example, why do you make Stanley, a character in* Send for the Million Men, *a robot, rather than casting an actor?"

The original reasoning behind Stanley the Robot was because I was doing shows by myself and I needed a partner on stage. So, rather than dealing with real people and their rehearsal times, I just built somebody. It was to free me up as a solo performer on stage to have another "person," or character, onstage. Non-equity! He's very cheap, just runs on a little electricity. Of course, he's much more complicated in other ways, so you spend a lot of time behind the scenes. But also he is intrinsically a draw; it's interesting to see this little guy onstage moving and talking. And after working with him for a few years, I understand the nuances of how to make him glance around the room, and little details like that, that really give him more life. It's an interesting development.

This connects with what we were just talking about: living with something for a while, instead of just starting something at the last minute. Does storytelling need all this technology? No, storytelling can happen on stage with nothing. Spalding Gray onstage alone, just talking, can be gorgeous. But that's not what I do. That's not what I'm interested in. So I'm not saying that storytelling needs technology or that technology needs storytelling, but that you can put them together to use the technology to emphasize what's important to you in the storytelling in a different way than just talking on stage.

For instance, in my piece in *Send for the Million Men* there's a moment when we're describing the night that Sacco & Venzetti are arrested, and we throw a projection map of a town onto a pile of suitcases. So it's a pile of suitcases, and then you turn on a projector and a suitcase turns into a little house. And we can move characters in front of it and such. And for me, that allows the story to be told without me having to stand there and describe all the little things that happen. It allows the beauty of that kind of image to be reflected, the calmness of that moment. I mean, nothing really happened, and then all of a sudden they were arrested. I use the technology to reflect this kind of serene, beautiful but very ordinary moment in the day that something gets switched. I feel it emphasizes the beauty and ordinariness of that moment. This is different from me saying, "And then nothing happened that day" or something like that. Of course I could figure out a way to phrase that with just words, but to make the show more varied, instead of me just talking for an hour and a half and giving a lecture, if you break it up and have this moment emphasized through these visuals and emphasize with the robot explaining stuff for a specific reason, it makes you more engaged as an audience member. At least that's how I take it.

What kind of education prepared you for who you are today?

I never took any design or theater courses in college. I was in Fine Arts doing sculpture, then I started building mechanical sculptures, then I started doing performance art. I went to Graduate School for Performance Art. At Grad School, I learned a lot of the technical side of things, the standard trappings of stage lights and sound design, etc., but I never took formal classes on how to build things, or mechanize things, robotics, or any of that. All of that has been self-taught or taught via experience.

I do believe very strongly that you need to be focused. You need a major. But you also have to have a liberal arts education, because I think a lot of what I do is fed from all the other stuff, the seemingly non-connected subject matter on other classes that I've taken.

History, great literature, Russian art, these interests were separate from my major, but have been important to me as an artist.

Any "words of wisdom" that you can offer any potential theatre designers on how to break into this business?

My best advice for college students is to keep doing something every day. Life can pull you in many different directions, and you want to always anchor yourself with what really interests you by reminding yourself on a daily basis, "This is what I want to do." Sketch something. Read about a designer or design you like.

ALSO understand that even if you are successful, you will not be spending every day eating grapes and drawing designs in a sun-drenched studio. You will have to negotiate, bill, pay bills, estimate costs—in other words, you will be an artist as well as a small business. Learn some business basics now, so that later it is "in your pocket" and allows you as much time for grape eating as possible.

To aide with your understanding of Joe Silovsky's work, check out:

Send For the Million Men https://vimeo.com/33452761

The Reddest Dirt In Oklahoma silovsky.com/theReddestDirtinOklahoma_ssllc.htm

What other questions would you ask Joe Silovsky if you could?

Do your questions demonstrate __specificity ___polish ___variation ____investment?

SKILLS FOCUS:
Research and Annotated Bibliographies

During the course of this semester, you will be asked to conduct research into theatre styles, artists, and companies on your own. In fact, we have already mentioned many examples in this book that you might be curious to know more about. How would you go about finding this information you seek?

It is natural in this day and age that we first think to go to the Internet for answers—and why not? If we have a straightforward question, such as "In what year did Shakespeare write *Hamlet*?" the most efficient way to find out that it was probably around 1601 is to do what has become almost an automatic action for many of us: open up a search engine and type search terms into that little empty rectangle, and then press "go."

When you use a search engine such as Google, in what order do your search results show up and why?

What suffixes or web addresses indicate that the source may be more reliable than others?

What strategies for search terms do you know that can help hone your results when searching online databases and the internet in general?

There are many instances in this course for which this "go to" action will be exactly what you need.

There are, however, other instances in which more in-depth research is needed. Whereas "googling" is often a single loop of searching for an answer and finding it, **research** refers to a process of asking questions and finding answers . . . that lead to further refined questions and finding answers, and so on. Research means vetting your sources and asking questions of them even as you are finding answers.

You should also be aware that you have access to restricted resources that will not show up in a general Internet search because you are enrolled as a university student. The university library pays a fee to be able to provide you access to exclusive journals and other sources that are not free to the public. These sources often contain information of the highest caliber because they are published by reputable academic journals that involve a process of vetting before publication. Anything published in a journal of this nature has been read by people considered experts in the same field in which the author is writing, and that panel of experts has given its endorsement to the work. That doesn't mean that opinions expressed in an academic journal are all agreed upon—you can feel free to agree or disagree with what is hypothesized—but you can be assured that expert group considered whatever you read an interesting contribution to the discourse in that area.

You will find yourself conducting research through both the university library system and public search engines as investigative questions arise in this course.

As you conduct research, it is helpful to keep a record of your sources and what you found useful in them. A simple way to do that is to create an annotated bibliography. An annotated bibliography is a list of your sources, where each source is followed by:

- a brief summary or description and

- an explanation of how you found that source useful.

This is what an entry would look like for Anne Bogart's chapter on narrative (this citation is in MLA format, though you may use APA or Chicago style if you are more comfortable with them):

Bogart, Anne. *What's The Story, Essays About Art, Theater and Storytelling.* New York: Routledge Press, 2014. 4–15. Print.

In this first chapter of Anne Bogart's book, she explores the relationship between storytelling, memory, and narrative. Because human beings strive to create cause and effect relationships, she asserts that stories are powerful tools—to teach, to enable, and to incite change. Since I am interested in investigating how theatre tells stories, I found this source valuable in helping me describe my ideal type of theater as one in which stories are more than merely entertaining—they can be transformative.

You may also be looking at archival video footage as part of your research, as well as other formats. Each type of source has its own standard for formatting, something that you can easily find out. Just "google" it yourself (search for "citation guidelines") or check out Purdue University's Online Writing Lab. They even have a great page about annotated bibliographies: https://owl.english.purdue.edu/owl/resource/614/01/

SUGGESTED ACTIVITY

Storytelling and the Environment
Take 2 photos (must be taken by you, not something pulled from Google) from 2 very different environments. Some examples are: a dining hall and a upscale restaurant, or a park and the interior of a Starbucks, or a tennis court and the library.

Image #1	Image 2
(paste image here)	(paste image here)

Then compare and contrast how each of these environments would affect how you would visualize the story of the following Haiku poem by Judith Ann Gorgone:

I thought your touch would
transform me but it made me
realize who I am.

- Describe how you visualize the story unfolding in these environments

- Decide how many characters and how would they look in these environments

- Would time of day affects the story?

- How do the environments indicate time changes?

- How do the environments change the mood of the story?

RECOMMENDED READING AND VIEWING

- *The Walls Come Tumbling Down* by Diep Tran

 In immersive theatre, audiences are breaking the rules—moving around, talking with the actors and molding the action.

 http://www.tcg.org/publications/at/issue/featuredstory.cfm?story=2&indexID=34

- "Chapter One: A New Kind of Drama," *The Dramatic Imagination* by Robert Edmond Jones

- "Chapter Two: Art in the Theatre," *The Dramatic Imagination* by Robert Edmond Jones

- "Chapter Three: The Theatre as it was and as it is," *The Dramatic Imagination* by Robert Edmond Jones

- The Lion King—Circle of Life—Helpmann Awards

 https://www.youtube.com/watch?v=2W_Zblr09Y0

- Interviews with designers (and playwrights and directors) can be found at

 http://americantheatrewing.org/videos/

- An interview with a designer that designs political events

 http://howlround.com/political-stage-design

Creating Theatre

" *I regard the theatre as the greatest of all art forms, the most immediate way in which a human being can share with another the sense of what it is to be a human being.* "

—Thornton Wilder, *A Woman of No Importance* (1893)

About the speaker:
In your own words:

" *Vacuum is all potent because all containing. In vacuum alone motion becomes possible. One who could make of himself a vacuum into which others might freely enter would become master of all situations. The whole can always dominate the part.* "

—Okakura Kakuzo, *The Book of Tea* (1906)

About the speaker:
In your own words:

So far we have focused on theatre from the point of view of an audience member by introducing you to different elements that are visible from that perspective. The performance is in a sense the "tip of the iceberg," and behind what you see there is an intentional and often intricate process of making theatre. Knowing what goes on behind the scenes can aid you not only if you decide to create some theatre yourself, it can also help you become a more informed and astute audience member.

The Butcher Men, **conceived and directed by Jeanette Oi-Suk Yew, published with permission**

CREATIVE COLLABORATION

In Chapter 3, you were introduced to the different areas of design common to creating the theatrical environment. Typically, these design roles are filled by personnel who work in collaboration with the rest of a **Production Team** (also sometimes called the Artistic Team). The members of this team usually include:

- *The Playwright:* who writes the script. Sometimes, a playwright creates a script on her or his own and then submits the play to playwriting competitions, theatre companies, or specific artists with whom he or she would like to collaborate. Other times, a playwright will be contracted, or commissioned, to write a play for a specific purpose. Later on in this chapter we will examine different models of creating theatre where the playwright is not always the starting point and where sometimes there is a team of writers instead of just one person.

- *The Director:* who upholds the overall artistic intent for this specific production through working with actors, designers, producers, and other personnel as production needs require. For example, with *The Lion King,* Julie Taymor worked closely with puppet designers and puppet engineers because how the puppets were constructed impacted the actors' movement significantly. The director is often looked upon as the starting point for the artistic intent, but later on in this chapter we will examine different models of creating theatre where the director is not initiating the intent on his or her own but is with actors, writers, and designers.

- *The Designers:* traditionally they are in areas such as Set, Costume, Lighting, Sound, Video, and Props (see the detailed list in Chapter 3); but again different

productions might require other designers in other specialties to join the team. Together the designers hone the particular creative vision for the production after a collaborative process with the director (and possibly the producer and playwright) to craft the theatrical environment.

- *The Producer:* who oversees the administrative needs for the production. Their duties can include fundraising, marketing, hiring personnel (including the director sometimes), ticketing, and more.

- *The Composer and Librettist:* are equivalent to the role of the playwright for musicals.

- *The Stage Manager:* who works very closely with the director in rehearsal and is the liaison between the director and all of the personnel that are involved with the production. After the show has its official opening, the stage manager ensures that things run smoothly.

This is just the core list of personnel who are involved with the creation process. According to the New York City Mayor's Office of Film, Theatre & Broadcasting, Broadway productions support an estimated 86,000 jobs annually (and there is more theatre going on in New York than what is on Broadway). In order to give you a sense of the other kinds of personnel, a sample chart is provided below. This chart illustrates a traditional organizational hierarchy, and it doesn't explain other, equally valid chains of collaboration. It is important to note that the modern day notion of the director being the pinnacle of the creative process actually developed in the late 1800s due to the changes in the overall production structure for theatre. Also note that the playwright is not listed because the assumption is that we have already picked a play to produce.

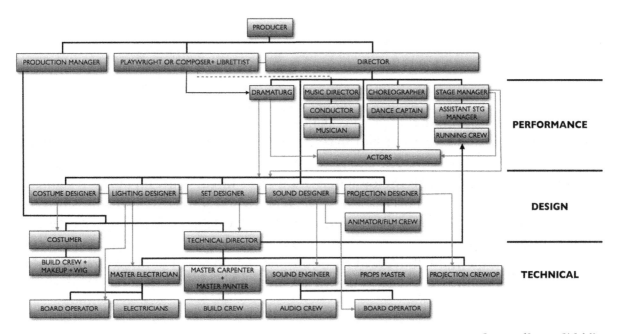

Courtesy of Jeanette Oi-Suk Yew

As you can see, this is a long list of people all trying to execute the artistic intent of the production so good **COLLABORATION** is necessary. As Jim Nicola, the artistic director of the New York Theatre Workshop, once said, "Without collaboration, you can't make a play." A good collaboration takes time and it requires compromises and trust. It is also a *practiced* skill.

Here are a few tips for creating a good collaborative process:

- Do your homework and be prepared to contribute ideas based on *informed* information or thoughts. Informed does not necessarily mean intellectual only; it can also be emotional. Have a point of view and be familiar with the material.

- Find multiple ways to articulate your ideas—speaking is only one way; sometimes you need to show your ideas.

- Practice active listening by taking notes and acknowledging teammates' opinions, experiences, and contributions.

- Expand and build on other's ideas.

- Give *constructive feedback* and always be prepared to explain why you are giving the feedback.

- Conversely, seek constructive feedback from your teammates.

- Share information and define problems in a clear, respectful, and nonthreatening manner.

What other advice for collaboration can you add?

It is important to note that good collaboration does not mean the team is in agreement all the time. It does mean that the team *supports the entire idea* and gives it 100% of their energy in its execution. The Broadway musical version of *The Lion King* took over two years to develop. Before the designers were even hired, Julie Taymor envisioned a circle as the primary shape for Pride Rock, the place where Simba is born and is featured in the opening song "Circle of Life." During the long development process, set designer Richard Hudson expressed concerns over the shape and eventually (through several meetings and some show-and-tell) worked with Julie Taymor to adopt a different shape. They did compromise on the circle idea by having the rock rotate in a circular pattern, fulfilling Taymor's original circle idea.

CONCEPT

The first question theatre artists ask before starting a project is: Why? The answer can be as simple as "it is fun" to "it offers a way to see each character in *Macbeth* as a human being with flaws rather that as a literary titan" to "it demonstrates to an authoritarian state the power of resistance through artistic expression." The answer does not need to be grand but it does set the *tone* for what the production would look and feel like and how it will relate to a given audience. This answer becomes the seed of the artistic intent, or **concept**, for a production. Sometimes this seed will die before it germinates, but in order to know that, theatre makers need to move on to the next level of questions:

- Why do you want to produce or present this piece NOW? What makes it relevant?

- Who is the intended audience for this production?

- What do we want the audience to walk away with intellectually and emotionally after experiencing this production?

By articulating the answers to these questions, the production team is starting to form an *artistic intent* for the production. In order to answer these questions, the team needs to delve deeper into the themes and figure out the focus of the production. Taking *Romeo and Juliet* as an example, many themes can be derived from the original Shakespearean text (we will call this the original source):

Step 1: List Themes in *Romeo and Juliet*

✔ The undeniable strength of love

✔ the recklessness of love

✔ the tangled relationship between love and violence

✔ the innocence of youth vs. the arrogance of age

✔

✔

When you look at different versions of *Romeo and Juliet,* as we suggested you do as a follow up to Chapter 1, you will notice there is a difference between which of these themes each production chose to focus. Perhaps you viewed the Royal Shakespeare Company's version, in which the innocence of who Romeo and Juliet are and the undeniable strength of their love take precedent. In contrast, in *R+J*, the film adaptation starring Clair Danes and Leonardo DiCaprio, recklessness and the tangled relationship between love and

violence are more apparent. Both productions had a modern audience but they are very different in execution because their concepts differ.

The next level of questions helps the production team to consider how the performance (by actors, dancers, musicians) and the environment (all aspects of design) support the overall artistic intent. Some of the questions to consider are:

Step 2: Exploring the Theme. Theme you are interested in exploring _____

- How can we make our intent clear?

- What is the big event in each scene? In the entire play? In the entire experience?

- What is the audience expecting to happen?

- How can we make it special, memorable, and surprising to an audience?

- How can these surprises clarify the story?

- What kind of audience relationship best supports our intent?

Please note this is not a comprehensive list. The discussion is just beginning and it will function more like a feedback loop. This is when collaboration is put to the test. Let us revisit the previous example of *The Lion King* regarding Pride Rock. The main reason that the set designer Richard Hudson was less interested in the circle as the primary shape is because he did not see the world that Simba was born into as being in harmony. He felt that the central conflict of the piece is the threat to the kingship, and that together with the theme of "learning to lead" convinced him that a more dangerous looking Pride Rock to start the production would better support these ideas.

PRODUCTION MODELS

There is a relationship between the choices an artistic team makes in how to structure their process and what they would like the final product to look like. After the production team is set and they begin the journey of solidifying the concept, it is time to consider what production model would be most suitable for bringing it to the audience. The following is a boilerplate for a typical production sequence.

A typical production sequence:

1. A producer or theatre decides to put on a specific play, or work with a specific director.

2. The play is selected with the director in mind, or the director is selected with the play in mind.

3. The rest of the creative team is assembled.

4. The director meets with the designers and others to share his or her initial impulses about the artistic intent and then they work together to develop a complete concept.

5. A timeline of tasks is created and space is rented.

6. Auditions are held.

7. Actors meet with the director around a table to read the play out loud and discuss it.

8. Designers and the director talk to actors about the entire concept and how it will be articulated.

9. Director and actors discuss the lines, character motivation, and overall narrative shape of the play.

10. Actors get up on their feet and their movements are set.

11. Actors memorize their lines.

12. Actors run through the entire play without stopping.

13. Designers submit their ideas to the technical personnel so they can execute their ideas.

14. Director and designers try out the cues using the space, which should have a nearly complete set upon it.

15. Actors are called to technical rehearsal, where they will walk through their set movements under the lights, allowing for adjustments to be made.

16. Dress rehearsals take place, where all of the elements are performed (hopefully) exactly as they will occur in front of an audience.

17. The first public performances of a play are usually called "previews" because the director is still able to make changes based on audience feedback.

18. Opening night marks the changeover—the director's job is done.

This boilerplate works very well for conventional narrative-based theatre that is being created within a typical hierarchical production team model. Differences in what type of performance is being prepared and in the composition of the creative team can cause deviations from this sequence. Here are a few examples:

Ensemble Theatre

Ensemble theatres tend to function more like a collective because they are a group of artists committed to working together time and time again to create many different productions. Since they are so accustomed to working together, their collaborative skills are highly developed and they tend to pick work that they know can be done with the individuals they have in their group. In some ensembles, different actors take turns doing administrative tasks, directing, designing, and even performing.

Non-Narrative and/or Non-Text Based Work

Rehearsals take on a very different look if one cannot sit around a table and read the script. There may still be a concept presentation, but the director will have to allocate time differently and get the performers up on their feet right away. Plays or performances without a text could be movement-based and/or require the actors to use improvisational acting, in which case rehearsals would be allocated to choreography or training respectively.

Work Requiring Special Training

There may be particular demands of a performance that require special training of the actors. One such example is the aerial theatre piece *Fuerza Bruta* (which translates from Spanish as "brute force"). The performers must learn to use specially designed equipment and train their bodies for the physical demands of the performance, and time must be given to coordinating the audience's movements around the performance space (which has no seating and requires the attendees to move about the space to watch different scenes take place to one side or another or above their heads)! Puppetry is another element in a production that requires special training and rehearsal time, as do singing and dancing.

Devised Theatre

Theatre is devised when a performance originates from an idea and is then created through collaboration that is often part of the rehearsal process. Devising theatre is a journey in which the end point is not known at the beginning. Casting would be done before knowing what role each performer would ultimately take on, and it is not uncommon for performers to be asked to participate in the process by contributing their own material and ideas to the mix. Devising can start from a question, such as "What is the impact of environmental health on human well-being?" or it could be drawn from a variety of sources, including but not limited to, a work of art in a different medium (a painting, a poem, a song, a novel), transcripts and interviews, or an historical event.

An important point to note is the overlapping nature between all of these different production approaches. For example, an ensemble can choose to work on a published play like *Romeo and Juliet* on one project and turn to a non-text based work for their next project. They could follow the traditional blueprint on one project and use a devised theatre approach for another, or they could combine the two sequences together. The Elevator Repair Service is a good example. They are an ensemble-based company in New York City. One of their recent pieces, *The Select,* is based on Ernest Hemingway's short story "The Sun Also Rises." They started the development of this piece through their fascination with watching YouTube videos of bandstand dance movement. Their early rehearsals were worked on mimicking these movements without an idea of what the final performance would look like or even what it would be about. It was not until a few rehearsals into it that they began to juxtapose the movements with Hemingway's text. Once the text was adapted, the process then followed a more traditional production sequence.

COMMERCIAL VS. NON-PROFIT THEATRE

As we further look at the different ways that theatre gets made, the question of money and funding comes up again and again. Making art costs money. In the United States, theatre makers must decide to raise and manage funds as a commerical or a non-profit entity.

Commercial theatre's main goal is to make as much profit as possible. Theatrical productions are the product they are marketing and branding (just like Coca-Cola), and because of that, what is produced is often selected because it has the broadest audience appeal. A type of theatre that seems to work well for this is a family-friendly musical, but there are other types of productions that have other draws: technical spectacle, big-name stars, a compelling story and characters. Since the primary source of income for commercial theatre is ticket sales, the productions are often tailored to be performed in the largest of theatre spaces where several hundred audience members, even thousands, can view a single performance. (The largest operating theatre in New York City is The Gershwin Theatre, which seats almost 2,000 paying customers and is currently running the musical *Wicked*). The production rents everything from equipment to the theater space and relies on investors for start up money. Musicals are very expensive to put on—there are 17 unions that regulate Broadway, for instance—and it often takes years before a show can recoup the costs of production. However, if the play becomes a popular success, then investors could get a great return on the risk they took. As long as a production is making money, it can keep running indefinitely without an end date. A long run often means replacing cast members and maintenance to the sets, props, and costumes.

Non-commercial, or **non-profit**, theaters are theaters that have a **mission statement** for their organizations. Their primary goal is to uphold this mission. As a result, individual donations, grants, foundations, and corporate sponsorships make up a significant portion of their finances and they are less dependent on ticket sales for revenue. The head of a non-profit theatre is called the artistic director. Her or his primary duty is not just to oversee the administrative needs but also to uphold the artistic *mission* and standards by selecting productions to be produced by their theater. For example, per its website, the mission for the New York Theatre Workshop (New York City) is to: "provoke, produce and cultivate the work of artists whose visions inspire and challenge all of us." Among its history, the NYTW has produced provocative works such as Jonathan Larson's *RENT* and Tony Kushner's *Home/Kabul*.

Look up a theater and its mission statement. Record it here:

What is an example of a play produced by this company and how does it exemplify that mission?

It is becoming more common for emerging artists to self-produce their own work instead of waiting for someone else to do it. Oftentimes, a piece in development has been accepted into a curated festival of new work, which secures a place for the play to be performed, but may not provide a budget. Or, an artist has not found an outlet for a performance and decides to rent rehearsal and performance space in order to make it happen. In this instance, artists often turn to crowdsourced funding through online platforms like Kickstarter. This added responsibility can change the process of making theatre because of the amount of time the artist must dedicate to producing as well as creating the piece.

BROADWAY VS. OFF-BROADWAY (AND OFF-OFF BROADWAY)

There is a lot of misunderstanding regarding Broadway. First of all, once upon a time, all of the biggest theaters in New York City were located on a street that runs diagonally through the otherwise grid-like layout of Midtown Manhattan: a street called Broadway. But to label a theater a "Broadway" theater nowadays has nothing to do with geographic location. Now, the only requirement that determines whether a theatrical production is a Broadway production or not is based on the *number of seats* in the New York City "house," i.e., audience capacity. That number is 500 or more. Hence any production that can allow for 500 plus audience members at a single performance would be considered a Broadway production. Lincoln Center Theater is a Broadway house but it resides at W 65th Street and Amsterdam, about twenty-three blocks north of Times Square.

Off-Broadway refers to productions that have 100 to 499 seats, and Off-Off-Broadway is for productions with fewer than 100 seats.

Because of the financial burdens and risks associated with producing theatre, Broadway theaters are most often occupied with big shows that involve visual spectacle and appeal to a wide audience base (after all, they have to draw several hundred people to see each performance!). Off-Broadway used to be synonymous with more experimental work, but it may be more accurate to say "unproven" work nowadays. An unknown playwright is not likely to have his or her play premiere on Broadway, but the production may be tried out in a smaller theater to see how it does. If a show is very successful Off-Broadway, it may be transferred to a bigger Broadway theater to reach a bigger audience. Many shows running in large Broadway theaters today had their first productions at smaller theaters in New York City, or in theaters elsewhere in the country.

Another misconception is that Broadway is synonymous with musical theatre. Although most Broadway productions are musicals, there are a good number of plays also. During 2013–2014, according to the Broadway League, 14% of the gross revenue came from plays other than musicals.

Lastly, Broadway *is* synonymous with professional. The reality is, any theatre that is done by those who have received training in this field is considered to be professional theatre.

Broadway (seats)	Off-Broadway (seats)	Off-Off-Broadway (seats)
example:	example:	example:
characteristics:	characteristics:	characteristics:

Theatre Outside of New York City

Regional theaters are defined as theaters that are outside of New York City, which produce a season of theatrical works. A season means that a number of different productions are to be produced for the public within a specific duration of time (usually between six to nine months). Regional theaters can be commercial or non-profit.

In 2013, the League of Resident Theatres (LORT), a national association for professional regional theaters, reported that 70 out of 74 of their members are theaters outside of New York City. However, many Broadway productions have their start at one of these regional theaters. Examples are the Barrington Stage Company's (Berkshires) *The 25th Annual Putnam County Spelling Bee* and American Repertory Theatre's (Cambridge) *Porgy and Bess, Once,* and *Pippin.* Even Disney's hit *Newsies* came out of New Jersey's Paper Mill Playhouse.

"Producing shows comes from my own voice."

Courtesy of Cheryl Weisenfeld

INTERVIEW:
Broadway Producer Cheryl Wiesenfeld

Throughout Cheryl's career she has been in the communication field as an editor, a writer, and a producer. She started her career as a magazine editor first at Popular Photography Magazine. *Next up she became a photography editor at* Forbes Magazine. *In between, she co-edited two books of photography, "Women See Woman," and "Women See Men," which were promoted widely around the country. Following her career in publishing, she became a producer of large-scale industrial events for corporations. She was able to flex her creative muscle, and produce shows that combined art, theatre, dance, and ideas, working with*

such luminaries as Andy Warhol, Lena Horne, Tony Bennett, Robin Williams, and Bill Irwin, among others.

Cheryl began her theatre-producing career in 1998. Broadway: "The Heidi Chronicles," "All The Way," "Rocky," "Vanya, Sonia, Masha and Spike," "The Gershwins' Porgy and Bess," "A Steady Rain," "Legally Blonde," "Dirty Rotten Scoundrels," "night Mother," "Caroline or Change," "Elaine Stritch At Liberty," and "Hedda Gabler." Off Broadway: "10th Anniversary Exonerated," "Play Dead," "In The Continuum," "Shockheaded Peter," "Talking Heads," "The Exonerated," "The Waverly Gallery." Film: Executive Producer "Elaine Stritch: Shoot Me."

Cheryl has won numerous awards for her productions, including the Drama League, Drama Desk, Lucille Lortel, New York Drama Critics Awards, and four Tony Awards.

She is on the board of Theater Resources Unlimited where she co-founded the TRU mentorship program established in 2007. The program to date has mentored over 200 commercial producers and self-producing artists. Cheryl speaks at schools and to many groups, as well as continuing to mentor. She is on the National Council of the Theatre Communications Group and The Honorary Council of Long Wharf Theatre, and on the Board of Silver Hill Hospital.

Cheryl graduated from Emerson College, and splits her time between New York and Connecticut with her husband Jerry Rosenberg.

One of the things that I like about producing is that you are able to put things that you believe in out into the world, to really give birth to them. What's your producing process? How do you choose your projects? What do you look for? What do you believe in? What do you look for in a script? How do you choose the projects that you do?

I choose projects in different ways. First of all, one of the givens for me is that I have to be open to it. My heart, my mind has to be open. It has to be in touch with who I am. And being in touch with who I am—it sounds kind of "yogic" in a sense, but I think there's some reality to that—that part of me has to be in touch with what's going on in the world. So my choices, for the most part, tend to be intuitive. They tend to be things that resonate for me, and I choose things that are socially, morally, politically based.

What I realized early on, when I first started getting into this business. It was more like, "Oh, I like Cate, I really want to invest with her," or "oh, that guy's doing that, I want to get to know him more as a producer." But at some point I realized that there had to be more than just "picking stocks," or just "picking shows." It had to come from a deeper place, and that deeper place was my own voice. Realizing when producers put their show out into the world they're trying to communicate something. In some cases it might be entertainment—they want to make people laugh or make people cry. What was CHERYL trying to say?

When I opened myself up to the world, I opened myself up to who I was, to the zeitgeist, and I realized that the things that were interesting to me were things that were more socially based. The first play I produced in 1999 was called *The Waverly Gallery*. It was produced Off Broadway at the Promenade Theater, and it starred Eileen Heckert in her last starring role. The play was written by Kenny Lonergan and was about a family and Alzheimer's. [Ed. Note: the play was a finalist for the Pulitzer Prize for Drama in 2001.] But in 1999 nobody was really addressing that. But it was a wickedly funny play. That

was something that was really interesting to me, and I chose to do it. It was the first time I brought investors in. We lost most of our money, but I loved that play. That play had resonance for me. And now, in retrospect, it was enormously prescient.

I started realizing that my choices all had things in common. *The Waverly Gallery* was about Alzheimer's. *The Exonerated* was about the death penalty. [Ed. Note: *The Exonerated* was produced Off-Broadway in 2002 starring Richard Dreyfuss, Jill Clayburgh, and Kyra Sedgwick; later stars included Jeff Goldblum, Peter Gallagher, Marlo Thomas, and Bebe Neuwirth.] Even my first Broadway show, *Elaine Stritch: At Liberty* [2002] was about a woman who had survived. Yes, she was certainly a legend, but it was about her life, it was about alcoholism, it was about her diabetes. It was about how to be successful in spite of herself. And that was really the foundation that allowed me to move forward and begin to choose my other projects.

That's a great answer. Producers, like artists, can have a vision of what they can give birth to and say, and what they can communicate to the world. Do you have a particular "mission" in your producing?

I had to determine what I was interested in. I chose shows because they resonated for me. I discovered that being a producer means you do have a voice by the projects that you choose, and at that moment a mission statement occurred to me. I wanted to create a mission statement for myself similar to what corporations, schools, or any institution would create. My mission statement is *"Changing the World One Theatergoer at a Time."* My mission and vision have enabled me to have a structure and a foundation for building my body of work. Now, that doesn't mean that absolutely every show fits into that! But most of them do.

We've been talking about how, as a producer, you have a chance to change public policy and people's perceptions.

We changed the course of the death penalty in the state of Illinois. Governor George Ryan had the production lock stock and barrel come to Chicago to perform exclusively for him. He was so moved by the play that he commuted the course of the death penalty in the state of Illinois. Now that is theatre in action!

What shows are you particularly proud of?

Really all of them. But here are some of my favorites.

The Waverly Gallery, just because it was really my first show as a producer and it was the beginning of my figuring out why I'm a producer. The fact it was about Alzheimer's, it was socially connected, and an important show that made it special to me.

Elaine Stritch: At Liberty was a perfect show to me, and as I just mentioned, *The Exonerated.* A really visual example was being at The Culture Project [a theater in New York City] in an audience (the theater held about 200 people) and performing the piece for a theater of death row inmates who had been exonerated. Imagine that! Imagine how electric that room was surrounded by 200 exonerees. We changed a lot of lives, we raised a

lot of money. We changed the course of the death penalty and brought it into the public's mind and eye.

What else? *Caroline or Change* was a great musical. Tony Kushner [playwright], Jeanine Tesori [composer]. It was Tony's first musical based on his childhood. It was not successful financially, but it was a group of very talented producers who came together to support this most worthy project.

In The Continuum, about HIV. We brought the play to South Africa and had it performed to an audience of women who were HIV positive and who had never seen a theatre production. Imagine how powerful that production was for these women.

Legally Blonde deals with women and empowerment, and it's an important show in terms of young women and the place they have in society, which is so very critical. But *Dirty Rotten Scoundrels* was a chance for me to jump into a Broadway musical, to network with people that I didn't know, and to really educate myself. Sometimes you choose things for different reasons.

What else, leading up to today? Many things! I LOVED *Vanya, Sonia, Masha & Spike* [winner of the 2013 TONY award for Best Play] because, again, it's a universal play about family and what's important in life.

All of these shows, you said they resonated for you. What do you look for in a script?

I can't really quantify it, but there's got to be humor, there's got to be something that really moves me. It makes me laugh, it makes me cry, and then I can't stop thinking about it. It's like a good novel. I have to be transported.

It's also imperative for me to do things that push me beyond boundaries, to get me into situations of fear beyond my comfort zone.

Most college students aren't aware of what a producer does. What are some of the tasks? What's your role in the collaborative process?

There are different kinds of producers. There are creative producers, who are the ones who either come up with the idea or they are the ones in the beginning that start the project. They generate the idea, they hire the directors, they think about who the team should be, and they construct their house. Like an architect. There are also producers who choose other producers' projects and raise money for them. If you are going to be a producer, you either need to have the funds or you need to have access to the funds. You need to have written it, or have optioned it, or have partners that have done that.

Choice is very important. If someone has a lot of money, and Meryl Streep, Hugh Jackman, or Nathan Lane is in it, of course you're going to do that show, because the chances of that succeeding is going to be extremely high. People who are lead producers need other co-producers to bring money to the table.

I think that a producer has to be a creative producer. I think that's most rewarding. That's the way you can financially succeed. That's the way I would encourage people who come into the industry. That's the way that you really learn how to be a producer.

You need good instincts about how to put things together. A producer is a person who puts things together, someone who's a good networker. Someone who likes to collaborate.

Someone who likes to have fun! Someone who can be a therapist and an advisor. But a lot of what producing is today is about bringing money to the table.

The only other thing I can say is to find your heart. You're working in this world, which is not an easy world at all. So find whatever your passion is. Maybe your passion is backstage. Maybe your passion is being a set designer, or a costume designer, a dramaturg, an actor, a playwright. Producing is not for the weak. You have to find things to keep you going. But I think one of the best skills is knowing how to put things together.

What other questions would you ask Cheryl Wiesenfeld if you could?

Do your questions demonstrate __specificity ___polish ___variation ____investment?

INTERVIEW:
Costume Designer Carrie Robbins

Carrie Robbins is a costume designer of more than 30 Broadway shows, including Class Act Grease *(original),* Agnes of God, Yentl, Happy End *with Meryl Streep, and* Cyrano *with Frank Langella, movies, television, opera and ballet. Her awards and nominations include the Irene Sharaff Lifetime Achievement Award presented by the Theatre Development Fund and the tdf/* Costume Collection *(2012), two Tony Nominations, five Drama Desk awards, and many others. In addition to Broadway, Carrie has designed for Lincoln Center, BAM, Juilliard, and the NY Shakespeare Festival. Known for her drawing ability, her work is featured in the* Time-Life Series Collectibles *and in her own book,* The Designs of Carrie Robbins.

"I try to do my best in everything. That's the only way I can live."

Courtesy of Carrie Robbins

All creative work starts with process, and goes on from there. I would love to hear how you come up with costume ideas. How do you analyze the scripts and then come up with concepts that create the character?

Well, of course you start with reading the script. Generally speaking, at this point, I have a kind of pictorial mind, so pictures just jump into my head. And sometimes they "stick" (even though I continue to do

other work). Sometimes they go away and are replaced by other images, and down the road I will have to sit down and draw it. I feel I am just sitting down and drawing that picture. It's already there and I'm just transcribing it. But after the initial read I usually will—let's say it's a play set in a certain time period, the Jacobean period. I have a lot of books, specific costume books, a lot of interior design books, and I will start to thumb through my books to make those pictures in my head more precise. I'll look at paintings. They didn't have photographs back then, but they have paintings. For Jacobean I'm going to look at the great painter Hilliard, who painted miniatures. I'll study those. Or if it's twelfth century, going back even further, you can't really get immediate portraits of the people in the play, so I might go look at early calligraphy. In the illustrated pages of the early calligraphy books they have people, little people. I'm trying to see what the people look like, that's the goal. Generally your plays are made up of people, sometimes animals, sometimes metaphors, but generally people. So I will do all that. Research is key.

Sometimes I will get the idea from talking to the director, which I might have already done even before reading the play. But if not, I will talk after reading, and he/she might say, "I see this as an absolute real recreation, like a movie." And if that's the case I'll really have to be spot-on. I'll have to take the paintings from whatever source and draw it until I feel I know through the clothing how the person puts himself together. It will enter my hands, so to speak. The connection is between your brain, your hand, and your mind's eye, and at that point I can get to the rather tedious process of drawing them out.

I sometimes draw until I feel the specifics of the research have entered my eyes and mind down into my hand. It's kind of odd. I then talk to the choreographer (if there's a choreographer). I talk to anybody who will talk to me.

I ask the choreographer what sort of movement on a very specific level the character will do. I want to get him the exact sort of shoe he needs, because if a dancer doesn't have the shoes to do the job the choreographer is asking him to do, we are all in trouble. It is their (the choreographer's) choice; I'm not going to get involved. If there is money in the production, I would like to be able to custom-make those shoes so that they also look right, but if not, I don't care, it will be neutral. It's more important that the dancer can dance. This is the mature me. In the olden days I wasn't quite this sanguine about it. [She chuckles.] I felt the design was more important than the dancer's ability to dance. That is wrong. The actor or dancer is who counts.

If I can, I talk to the actors and get a sense of what they think about their character. I like to think that by the time I finish talking to as many people as I can talk to and putting in as much information into my brain, between me and the director and whomever else, that I could actually design my way through the character's entire 'closet'. And then it becomes relatively easy, if I can see that. I can 'thumb through' their mental closet and I can say, well, let's see, this is springtime, or winter. What do you have in here for winter? The characters become real to me, and I just go through their drawers and their closets and I pick out what seems appropriate for the particulars of what the play sets up.

Now if it's a metaphorical play, or if it's opera, the parameters are a little different. Often the director has in mind a more overarching umbrella of an idea, perhaps a metaphor that he or she wants to apply to the piece, and then that's going to require a lot more

conversation. I need to think more about that metaphor and how it's expressed in clothing. Sometimes that's problematic because it's much easier to do metaphorical scenery—"I see it on a big rake and it's all black, and there's a touch of red"—that's a fairly trite example, but clothing is connected to people and behavior. I find that actors still prefer to have a pocket to stick their hand in and a chair to sit on. There's all these plays that directors will do and they're set in some strange place, and there's no chairs. So a lady in a fancy gown has to sit on the floor. I don't know . . . that seems odd to me!

Since Grease *is such a popular show, could you give specific examples about how your concepts on costume design influenced the creation of the script of* Grease *for the 1972 Broadway production? It was a huge hit. When it closed in 1980 it was the longest run on Broadway at that point.*

The set designer of *Grease* has just had a book published on him, and Ken Waissman, the producer, was at the book signing along with me. Ken Waissman regaled us with memories of *Grease*. It has become a really iconic show.

But at the time we barely got it on. It started downtown, at the Eden Theater, which is now a movie house.

Off-Broadway, right?

Oh, yes. At the time there was no Off-Off-Broadway that I remember, except perhaps *LaMaMa*.

How did you become involved in it, and how did your designs perhaps influence the actors? [Ed. Note: Carrie Robbins received the Drama Desk award for Outstanding Costume Design in 1972 for her work in Grease, *and was also nominated for a TONY for Best Costume Design.]*

It was directed by a very interesting director named Tom Moore. He is now not so much in this business, but was very active back then. It was choreographed by Pat Birch, who went on to do a ton of other choreography, mostly for Hal Prince. She was Hal Prince's go-to choreographer.

The director and Ken Waissman wanted something that looked very real. Not like today, where everything is very flashy, with beads on everything, and sequins, and matchy-matchy coloring items, very high design! Ken used the word "documentary." He wanted the REAL thing. He wanted everyone to look REAL. Like these were REAL kids from a REAL high school, and we wanted people to understand that their problems were REAL. These people were absolutely real. That was very important to Ken and Tom. On top of it they had so little money that it would have been impossible to create fancy beaded costumes like those now on Broadway anyway! I did almost all the costumes out of vintage clothing (meaning real clothing from the 50s). When it came to doing the Poodle Skirt, I took the bath mat in my house, which was pink, and cut it apart and made the poodle dog that I sewed onto a grey felt circle skirt.

I had tons of research pictures. I chose the poodle because it was a popular motif and because I like dogs. There were also authentic "scatter pins" in sets that I found. I

managed to find almost everything I needed. The only other thing I made was for the Dream Sequence, where Frenchy dreams she wants to become a hair stylist. I made those ponchos from shower curtains, because that's all I could afford.

It was such a huge hit it went on to Broadway. I never got a chance to fix anything. With the exception of a custom made pair of tight Danny Zuko pants, *Grease* went on to Broadway with the same costumes, which saved money! In fact, when Frenchy dyes her hair (she figures she's a great hair stylist) and she makes it a terrible orange, she comes onstage and gets a big laugh. We didn't have money to create an orange wig. I got a very, very cheap wig that was either brown or auburn, and I got a huge handful of permanent orange magic markers. Strand by strand, the wardrobe guy and I painted that wig until we got it to a solid orange hue.

Segue to YEARS later—it ran I think almost nine years—so about five years in I went down to the theater basement and I see the wardrobe guy sitting there with Frenchy's wig looking a little dull, and a ton of orange permanent magic markers. And I said, "What are you doing?" and he said, "I'm putting the coloring into Frenchy's wig." And I said, "Do you know that we're on Broadway now and we're a hit! You could have an orange wig MADE. You needn't do that!" And he said, "Oh no, this is what is wonderful about Frenchy's wig. I'm doing it the way FRENCHY did it!" [She laughs.]

It all came out of necessity. Because *Grease* became GOOD, necessity became iconic and The Way to do things. Which of course is rather silly, but . . . I think people are somewhat superstitious about things like that. Necessity makes you do these things, and then they become The Way to do them.

What a great story! Any other important ideas that you would like to share about costume design, or the field in general? I know you taught costume design at New York University for years. How do young people start if they want to design costumes?

Sketching is old-fashioned, but I think the importance of being able to sketch down your ideas on a piece of paper in order to show it to a director is a very useful thing. We (costume designers) don't have drafting like a set designer does, but somebody is going to take that costume drawing, good or bad, clear or not, and put numbers (dollars) on it. If you're doing a Broadway show and someone puts numbers on it, it's going to start at $5,000 or $6,000. Somebody's money is rolling around, and I think it's the designer's obligation to show people exactly what we want/expect so that the price assigned to the costume is accurate, and then the shop can be held to deliver that product. This is what I want to do, this is what our collaborating team agrees we want; we all see it, and then we go on from there. We are all "on the same page."

And this process of sketching out ideas, presenting them, revising them, re-presenting them, is how I've always taught. I also try to have a conversation with the producer. Costume designers are generally chosen by the director and hired by the show's producers. Many directors like working with someone they've worked with before. If the director doesn't have someone in mind, the producer may jump in and suggest a designer. And sometimes, the set designer (who is usually hired first and is on the project the longest) might suggest a costume designer. You often see teams of designers and directors that like to work together on show after show.

When I first worked on *Grease,* I think I was chosen because the producer, Ken Waissman, knew me. We were both from Baltimore, and he knew my work. In that book I mentioned on the designs of Douglas W. Schmidt at the Drama Bookshop there's an iconic sketch as centerfold, a double-page spread of the set that Doug did for the set of *Grease.* I think it's safe to say that *Grease* wasn't either of our best work, as it was so compromised by the lack of money, but at the time it was "right." I know that I did my best. I'm sure Doug did too.

Once I worked on a wonderful play based on a short story by Isaac Bashevis Singer ("Yentl the Yeshiva Boy"). Mr. Singer talked in metaphors. I was having trouble with some of the costumes. He said with a heavy Jewish accent, "Here's the thing that you must always remember: when things are difficult, you have to think of yourself as a river. When the river is flowing to the sea, but there are big boulders in its path and the water cannot go through, it merely goes around. And so, it finds its way to the sea. So when there are boulders in your path, you, like the river, must just go around to find your way to the sea."

What other questions would you ask Carrie Robbins if you could?

Do your questions demonstrate __specificity ___polish ___variation ___investment?

CASE STUDY:

The Laramie Project by Moisés Kaufman and The Members of Tectonic Theatre Project

Reading a Play Script Devised from Interviews

When you were assigned to read *Doubt,* we mentioned that introductory notes to published play scripts can be a great source of information for you as you prepare to read. *The Laramie Project* is an example in which the introduction by company leader Moisés Kaufman, the "author's note," and the following production history, character list, and notes, are all indispensable to understanding both the creative process and the concept behind this play.

Kaufman's introduction explains the types of projects in which Tectonic Theatre Project engages, and why he was drawn to create a play that engaged with the community of Laramie, Wyoming, in the aftermath of the murder of Matthew Shepard.

The author's note section tells us more specifically about the unique process used to create the script we are about to read. Rather than arising from the imagination of a single playwright, this play was written from interviews conducted by members of the theatre company on several visits to Laramie. The interview transcripts were then culled and arranged by several members working together after a workshop process. Though the term is not mentioned in the note specifically, this does fit under the umbrella of what we have previously labeled **devised** theatre. How were the company members to know what they would learn in the interviews? How they would personally be affected by the community? Since their first interviews were conducted just a few weeks after Matthew Shepard's death, the outcome of the trial for those accused of the murder was not known at the time they started the project either.

The production history that follows the author's note follows a well-established formula that is dictated by the contractual agreements of publication. It tells us where an audience first saw this play, who the key members of the production team were, and who played each role in the play. It also often lists the Off-Broadway and/or Broadway premiere (many times there are changes to the creative team or cast in these subsequent productions but there was not much difference in that regard between the premiere of this play and it's Off-Broadway run). In this particular production history, there are several roles listed after each actor's name, and many of them play themselves as one of those roles—this will be a significant element of this play's relationship to its audience.

The character list is very long—over 66 names are listed—and yet we have already learned that the show is performed with a cast of eight actors. This means we are looking at a play in which each actor will play multiple roles. When we read the final notes about the staging and the text, we also learn that the stage should be viewed as a stage, with props and costumes that are not being used within view of the audience. Rather than aim at illusion, this play aims to activate the audience's imagination to couple with suggestions of different characters and places. Finally, we read that the building blocks of this play are not scenes but often shorter units of theatrical time called moments. We are to look to the juxtaposition of these moments to create meaning and resonance throughout the play.

We encourage you to let all that we have learned from this introductory material in this script influence how you envision this piece unfolding in your mind as you read. Instead of imagining the actual locations in which the action takes place, how might these places be suggested? Instead of seeing each of these characters as a unique face and person, imagine a layering (not unlike Anna Deveare Smith's *Fires in the Mirror*, mentioned as an example in Chapter 2) in which we see both interviewer and interviewee in one body.

Use the space below to sketch out what the stage looks like in your mind's eye:

CRITICAL QUESTIONS

1. How would you describe the structure of this play? What does the company's name, Tectonic Theater Project, have to do with this structure?

2. Approximately how many characters appear in this play? Approximately how many actors are needed in order to perform? How would the effect of this play change if you were to cast an actor for each role?

3. How is the audience guided through the quick changes from character to character in terms of "road signs" in the text?

4. What information is withheld in order to be revealed later? How does that controlled revelation of information create the narrative?

5. Why do you think several company members appear as characters in this play?

6. How does knowing that the characters on stage are created from interviews, and that the events of the play really occurred, influence your experience of it?

7. How would you answer the question Kaufman posed to his company: "Is theatre a medium that can contribute to the national dialogue on current events?"

8. What do you think the concept for this play is?

This play is a bit more challenging to map, as we did for *Doubt*. Instead of scenes, the acts are arranged into "moments." Here is an outline of the first part of Act 1, moment by moment:

A Definition	We are introduced to the project, see a company member transform into his interview subject, and "meet" several people from Laramie who describe the community.
Journal Entries	Company members speak about how they felt about going to Laramie to work on this project.
Rebecca Hilliker	This is a monologue from the head of the University of Wyoming theatre department, a character we briefly met in the first moment. She talks about how she felt when first contacted by the company about the project.
Angels in America	This is a monologue from a theatre student at the University of Wyoming, another character we briefly met in the first moment. He discusses how he got into college doing a monologue from *Angels in America* and his parents would not come to see him because the character he played was gay.
Journal Entries	Company members relay their first impressions of Laramie.
Alison and Marge	We are introduced to two social service workers who talk about the culture of Laramie. At the end of the moment, Marge asks what the intention behind the project is and when she is told that it will eventually be shown in Laramie she says she won't tell everything.
Matthew	We first hear from people who knew Matthew, including a friend of his.
Who's Getting What?	This is a monologue from Doc O'Connor, the outspoken cab driver about his suspicions about gay life on the down low in Laramie.

SKILLS FOCUS:
Being a Great Audience Member

As we have discussed before, a theatrical environment includes the audience's relationship to the performance. How audiences should behave has changed throughout history (for example, it is no longer acceptable to throw tomatoes at the actors), and at this junction we are on the verge of change again due to the saturation of cell phones and social media in our moment-to-moment lives. Theatres are reacting in one of two ways. Some are trying to embrace the trend, experimenting with "tweet seats," which are dedicated seats for specific audience members who are encouraged to do a play-by-play sharing on social media during the performance. Others are trying to force limits on cell phone use, and several new theater buildings now have the ability to block reception. If you remember, when we introduced the concept of the fourth wall in Chapter 1, we also shared some incidents in which breeches of audience etiquette, such as cell phones

ringing, disruptive audience members, or the taking of photos, have caused an actor to actually stop a performance.

While we are trying to figure out how to deal with cell phones and social media, the best rule of thumb is to respect the space and comfort of your fellow audience members. This is important because, depending on the intended audience relationship for a production, expectations for your behavior can change. However, there are a few general points to consider:

1. **Arrive early to the performance, and sit in your assigned seat (if you have one)**

 Performances usually begin promptly on time, and you will likely not have access to the theatre after the window for "latecomer seating" has elapsed. Some performances, depending on the relationship established with the audience, don't allow latecomers in at all. It is up to the discretion of the production team if having people come in late will be too distracting for the performance. Conversely, if better seats than yours are conspicuously empty a few minutes before the show, resist the urge to upgrade. If the people assigned to those seats come in late, then you will be part of the disruption because you will be displaced (and then you won't get to pay attention to the performance either).

2. **Turn *off* your cell phone (no really, entirely off)**

 Putting it in vibrate mode is not the best solution because it does produce a sound and, believe it or not, there have been cases where the sound system in a theatre has picked up a cell signal and broadcast a voice mail being left for an audience member. Needless to say, it was very embarrassing for the audience member. Depending on the set up of the seating, even just looking at your phone to check the time can be a disruption. It is noticed so often from the performer's perspective that there is now a nickname for the illumination reflected on an audience member's face as he or she activates the phone light: "fireflies." They see you, and other audience members probably can too.

3. **Don't attend the performance hungry**

 Unless you are going to see a show that takes place in a pub, it's probably a good idea to abstain from eating in the theater. Yes, it is about noise level again—and also hygiene in terms of leaving behind food particles that can attract rodents or create a general mess. If you must have a cough drop or candy to stave off a dry throat or a cough (which may be disruptive in itself), please plan ahead to avoid the necessity of digging around in cellophane bags and fumbling with crinkly paper wrappers.

4. **Be aware of your limited personal space**

 If you have to cough, cover your mouth. And if you have a lot of personal belongings with you like a large winter coat, a backpack, a purse, or bags from your

shopping spree, it is good to check them if possible so that you are not spreading over to other seats. If you can't store them in the coatroom, try to tug them as close to you as possible.

5. **Be attentive to the performance and save commentary until the end of the show**

 First of all, try to stay awake. This is self-explanatory, and if you are very tired, it might be good to skip seeing the show that particular day. While the actors appreciate your responses during the show in the form of applause, laughter, and even a coveted gasp of surprise, generally it is not a good idea to talk to the characters on stage or to your neighbors during the show. Furthermore, even if you are assigned to see the show for class and must write about it, refrain from taking notes during the performance. If there is an intermission you can jot down some thoughts then, and after the performance as well. (And keep in mind that if a cell phone backlight can be distracting, what attention a tablet or laptop screen could attract!)

6. **Don't worry about dress code**

 In general, most theaters do not have a dress code, and in some shows, like *Sleep No More* where you are expected to walk around, it is good to wear something comfortable. So check the website and ticket information of the specific show your seeing to make sure.

What other advice can you come up with for audience behavior?

SUGGESTED ACTIVITIES

1. Go to see a live performance, ideally one in which you are able to read the script beforehand. Write a reaction to what you saw. Be sure to address the following prompts in your response:

 - Describe your overall aesthetic experience. What did you notice upon entering the performance space? How did the play unfold before you? What patterns or structure did you notice? What connections can you make to the human experience?

 - Compare what you see on stage—the "final product" per say—with what you imagined in your mind's eye as you read the script. In what ways were your expectations met? What was surprising to you? Include specifics.

2. Research the following companies and/or others suggested by your instructor by visiting their websites and look up their works on the Internet.

 The Wooster Group: http://thewoostergroup.org/twg/twg.php?company
 Steppenwolf Theatre Company: https://www.steppenwolf.org
 Elevator Repair Service: https://www.elevator.org
 Pig Iron Theatre Company: https://www.pigiron.org
 Rude Mechanicals: http://www.rudemechs.com
 Lookingglass Theatre Company: http://lookingglasstheatre.org/
 Gob Squad: http://www.gobsquad.com
 SITI Company: http://siti.org
 Cornerstone Theater Co: http://cornerstonetheater.org

 After learning about them through their websites and watching some of their works, pick two companies you are interested in and compare and contrast their production processes. What was the history of their productions? Do they devise works often? How are their members identified in terms of personnel? What was their process?

RECOMMENDED READING AND VIEWING

- *The Laramie Project,* a play by Moisés Kaufman and The Members of the Tectonic Theatre Project. New York City: Vintage Books, a Division of Random House, Inc., 2001.

The Performer

>❝*All the best performers bring to their role something more,*
>
>*something different than what the author put on paper.*
>
>*That's what makes theatre live. That's why it persists.*❞
>
> —Stephen Sondheim

> About the speaker:
>
> In your own words:

An actor uses his or her body as the medium for art; and, much like an athlete, even those with a natural acuity must practice and build skills over time in order to execute effective performance.

Unlike film actors who can repeat the same scene over and over until the director is satisfied, actors who work on the stage must deliver sustained and consistent performances. They must execute the performance from beginning to end each time, and they must keep their way of performing similar from night to night. They must also use their body language and voice to communicate to audiences—even those who are sitting far away in the back row. This necessitates an adjustment from everyday speaking and gesture, which humans develop intuitively mostly for one-on-one communication. To this end, an actor must have awareness of his or her body and the way in which it communicates, and control those methods of communication expertly.

Actors rehearsing for a Commedia dell'arte performance on March 3, 2011 in Barcelona, Spain.
© *Christian Bertrand/Shutterstock.com*

An actor's performance must also fit with the style of the piece in which he or she is performing. For example, if an actor is cast in a realistic drama, he will be expected to embody a fictional character in a believable way. If he is part of an ensemble working on a physically-based piece, he will be expected to demonstrate virtuosic control of his body.

Actors from Tribuene Teatro in Madrid, playing *La Casa de Bernarda Alba*, **written by Federico Garcia Lorca, during the Festival of Theatre, July 14, 2011, in the Canary Islands, Spain.**

Image © criben/Shutterstock.com

Life is a Dream **adapted by Margarita Espada-Santos from the play by Calderon, Stony Brook University (2014).**

Courtesy of Margarita Espadad

General goals of an actor's performance include:

• Sustained throughout

• Consistent from performance to performance

• Intentional and controlled in terms of execution

• Compatible with the style of the play or performance

If these are the general goals of actors' performances, how does an actor best prepare to do his or her job in theatre?

TRAINING

An actor can choose which type of acting training she or he would like to pursue. Just as in sports where, for instance, a soccer goalie will practice catching balls kicked at the net over and over again, actors also build their skills though exercises that only contain a part of what they will need for a complete performance. Actors may do these tasks or exercises in a class of their peers in order to gain insight from feedback and their analysis of others' work. You may hear actors describe their training through who they "studied under." This is more than just prestige, for those who work in theatre, who someone was able to learn from can tell us about their performance style and focus.

For most of the history of the art form, training methods have focused on enhancing an actor's presentation (how well the actor can be heard and understood). Before the advent of modern psychology in recent history, humans had a very different sense of their identity as well, so what it meant to play a character who was different from oneself meant something else than what it means now in our post-Freud saturated world.

Regardless of the trends in performance, there were by all accounts powerful actors in every era that managed to command attention and elicit an emotional response from their audiences. But how? It isn't easy to determine what acting looked like in bygone eras before recording technology. We must rely on second-hand descriptions and analysis. Through journals, reviews, and other writing, we know that the first actors (at least the ones in ancient Greece) were most praised for their speaking voices. It was the most important tool of the actor to be able to be heard throughout the large outdoor theatre, in which audience members might be coming and going at any given time (this was not because they were being rude, but because performances were done in day-long events).

In the time of Shakespeare, rehearsal periods were very brief and focused mostly on learning when actors were to enter and exit scenes. Actors didn't worry about playing characters during these times—that was reserved just for performances in front of an audience. Then and for a long time afterwards, actors would usually stand on stage close to the edge, in front of the nearest audience members, and deliver their lines out to the patrons rather than direct their speaking to the actor in the scene. That doesn't mean that actors were not concerned with communicating their roles. In fact, there is a passage in Shakespeare's *Hamlet* in which Hamlet gives some acting coaching to traveling players. Among his advice: ". . . let your own discretion be your tutor. Suit the action to the word, the word to the action, with this special observance, that you o'erstep not the modesty of nature. For anything so overdone is from the purpose of playing, whose end, both at the first and now, was and is, to hold, as 'twere, the mirror up to nature, to show virtue her own feature, scorn her own image, and the very age and body of the time his form and pressure."

What is Hamlet's advice in your own words?

Training was largely done "on the job" through apprenticeship, and actors would learn to play a type of role that they would then keep for the duration of their careers. (For example, some actors played leading men, others played comedic roles, and so forth.) Training and preparation were the individual responsibility of the actors themselves.

As theatre changed with the times, the coming of the modern era brought about the first attempts to standardize acting training, spearheaded by the earliest theatrical directors (the position of director is a relatively new one in theatre). They all had their own ideas about what would bring about the most powerful theatrical performances out of their actors, but most put emphasis on practice and preparation over raw impulse. Over time, certain methods have gained traction and have spread from one theatre artist or company to other artists, companies, and schools, each of which might add their own spin to the basic principles. Generally (and somewhat reductively), these methods can be put into two categories: OUTSIDE IN—those that put primary focus on physicality, and INSIDE OUT—those that put primary focus on psychology.

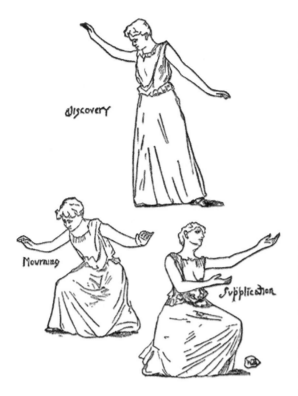

discovery

Mourning

Supplication

Actors' training can help them be prepared to excel in the skill areas that different pieces of theatre demand—some will benefit from an outside-in approach and others from a more physically-based approach. Neither is inherently better than the other; it is all a matter of context. For our purposes we would like to focus on one example for each.

OUTSIDE IN: Delsarte's System

Francois Delsarte was an aspiring performer in the nineteenth century in Paris. The nineteenth century was a time in the world in which many great scientific discoveries and theories were being made—from evolution to electricity, from the periodic table to germ theory. People were excited by the potential science had to explain all of the mysteries of the world. Delsarte was dissatisfied with the training he received and turned to scientific method to study and encode all the elements of the body and how they communicate. He conducted many hours of observation of human behavior and interaction in different contexts, among diverse groups of people. He started to notice commonalities and began to build an index of coded human behavior. His "Science of Applied Aesthetics" examines how movement, gesture, voice, and breath all contribute to communication. It was groundbreaking in how it was able to quantifiably explain what had previously been left up to "inspiration" or other vague notions. Acting became more than just saying the words; how one delivered lines and exhibited body language was vital to the art. The following quote is from Delsarte's address to the philotechnic society as published in Genevieve Stebbins' 1886 book *Delsarte System of Dramatic Expression* (Delsarte himself never compiled a book outlining his methods during his lifetime):

> "I am at least certain of having determined the fixed basis of art, realizing in so doing, that which serious minds had considered impossible. Thus, gentlemen, and in virtue even of the immutability of the basis of art, aesthetics, lost to-day in the chaos of oratoric fantasies, —aesthetics, henceforward disengaged from all conjecture, will be truly constituted under the severe forms of positive science."

What is Stebbins saying in your own words?

With such a lofty promise, it is no wonder that when his protégé, Steele Mackaye, brought Delsarte's system to the U.S., it seized upon the popular imagination and was soon seen everywhere—from adult cultural clubs to children's schools.

Delsarte developed this study of the symbolic meaning of bodily communication without modern psychology, but that doesn't mean that he discounted the synergy between what he called "the trinity" of life (physical manifestation), mind, and soul. Training begins with relaxation, balancing exercises, and isolation exercises; then it guides the practitioner through a series of modules focused on the expressive properties of different parts of the body. The illustration above is from Stebbin's instructional book on Delsarte's teachings, but if you want to see what this system looked like embodied in actors, you need look no further than silent films.

Modern dance owes its roots to his scientific approach to the physicality of acting, and there are several practitioners who still use Delsarte as a foundation, often integrating influences from yoga and other Eastern movement-based practices.

Additional examples of "Outside In" acting training:

INSIDE OUT: Stanislavski's System

Born in Moscow a few years before Delsarte's death, Constantin Sergeyevich Stanislavsky was destined to become the most influential theatre artist and theorist to make contributions to acting training in the twentieth century. He began practicing theatre as a teenager, and gradually convinced many other practitioners that if actors were to be effective in the modern age, the primary goal of performers should be to be *believed*. Instead of merely worrying about effective *presentation,* the actor has a responsibility to embody the *representation* of his or her character on stage. The system he developed was the perfect complement to one of the new trends in theatre at the time: Realism, in which complex and nuanced characters are placed in tightly constructed narratives.

Stanislavsky's system tasks the actor with analyzing the text he or she is about to perform. In this analysis, careful attention should be given to details that communicate information about the characters and about the world of the play. In this manner, actors can build a comprehensive portrait of character that is consistent with the script, and use their conclusions as an anchor for their acting choices (much like a member of the production team analyzes a script to create and refine an artistic concept and design choices, as covered in the previous chapter).

Actors are also asked to determine their characters' motivation, to take the action that they do in the script, and also to define the characters' goals, or objectives. Every action that a character takes in the play should be to try and achieve his or her goal.

Stanislavski developed the concept of the "magic if" to help actors put themselves into the story as the characters. An actor should ask himself, "What would I do if I found myself in this situation?" In order to be able to be present in the situations of the play as if they are happening for the first time to the character, actors complete exercises to hone their skills in relaxation, concentration, and imagination. It is only after an actor has developed a sense of herself as the character that she can physically embody that character on stage with believability. Toward the end of his career, Stanislavsky himself clarified the cyclical nature of emotional state and physical expression in his method, something that has only been bolstered by recent scientific study.

Additional examples of "Inside Out" acting training:

We have chosen examples in which the outside-in approach came first chronologically, but not all contemporary actor training focuses on psychology. Look into the mime and mask work of Jacques LeCoq, the physical approach to actor training created by Jerzy Grotowski (yes, the same practitioner who came up with the "poor theatre" equation of Actor + Audience = Theatre), and the Viewpoints vocabulary and training developed by Anne Bogart for contemporary approaches to actor training that could be labeled "Outside-In."

How might an actor prepare for a role in the most recent play that you saw?

What about that preparation might be similar and what might be different from an actor preparing to play an ensemble role in *The Laramie Project*?

PREPARATION AND REHEARSAL

Training involves general study and skill building for an actor. Preparation and rehearsal refer to everything an actor will do to prepare for a specific role. Depending on what style of performance is asked of him or her, preparation and rehearsal can be quite different. In a typical production process, preparation for the actor begins at the audition, where an actor prepares by choosing a monologue to perform that would give the artistic team a good idea of what the actor would do in the context of the particular production (such as preparing a comedic monologue in verse for an audition for a play by French comic writer Molière, who wrote in rhyming couplets).

After casting, an actor will be expected to spend time outside of rehearsal reading and re-reading the script, memorizing lines, and engaging his or her imagination in the character's circumstances and psychology (depending on the director's approach). This ensures that time in the room together can focus on making choices about where the actors should move and when, and how best to illustrate relationships, execute comic timing, and/or relate to the audience, among other things. Other times, directors like to have actors contribute to the content of a show through workshops that involve improvisations, such as in some devised theatre processes.

Improvisation

Most of us associate improvisational acting with comedy, which is only one type of improvisational acting. Improv comedy, made even more mainstream by the popular television show hosted by Drew Carey—"Whose Line is it Anyway?"—comes out of a robust live theatre tradition that pulls in crowds to see late-night shows in which the content is largely undetermined before that night. Companies like Second City in Chicago and The Upright Citizen's Brigade in New York City are built around this type of improvisation.

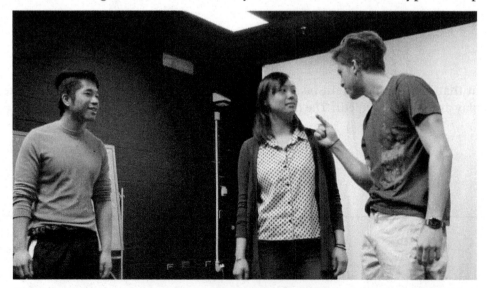

Cast members Xiao Yuan, Rebecca Anderson, and David Bonderoff of the 2014–2015 Prevention Through the Arts class rehearsing improvised scenes. *Courtesy of Elizabeth Bojsza*

Not coincidentally, both of these companies offer extensive opportunities for training. It is a fallacy to think that just because a performer is working without a script, he or she does not need to do any training or preparation—if anything, the opposite is true.

Improvisation is also used in non-comedic contexts. One such application is drama therapy. Drama therapy involves role-playing and other activities designed to help participants with empathy, strategy, and perspective. For example, a drama therapist may assume a role of a family member or friend of the participant, enabling him or her to practice a difficult discussion. Another application of improvisation is in community-based work, in which the emphasis is not on individual healing, but on building and strengthening community through dialogue.

Improvisational actors must practice their craft in order to train their impulses, hone their creativity, and be comfortable and competent thinking on their feet. The basic principle of improvisational acting, whether for intentional comedic effect or for other applications, is to always agree with what your scene partner or partners brings into the scene, and to build upon it. This principle is called:

"Yes, and . . ."

Imagine that you are on stage in an improvisational scene. You and your scene partner have been given the scenario of a dysfunctional family dinner. In your head, you have been working on things that you might contribute to the scene as a morose tortured teenager, but when you enter the scene your partner calls you mom. Guess what? You are now the mom in the scene, despite the fact that this does not agree with what was in your head. You have to agree—say "yes"—and then build on that choice—say "and"—by adding in your own contributions.

Improvisation and Community-Based Work

Much of the community-based work in the United States that uses improvisation is derived from the work of a South-American artist by the name of Augusto Boal. His techniques of using improvisational acting to foster dialogue about difficult issues in communities have been applied to everything from immigration to school bullying to workers' rights.

Boal came to believe that traditional theatre—in which an actor has all of the power to be seen and heard and audience members must sit quietly and listen to whatever the actor says—is inherently oppressive. Since he was interested in exploring strategies for combatting power imbalances outside of the theatre, he realized that he had to change the relationship inside the theatre as well. Hence, his concept of the **spect-actor** was born. In Boal's performances, there was no distinction between a spectator and an actor. A group of initial actors might begin the scene, but there would be no resolution. Instead, audience members would be invited to come up on stage and "sub in" for characters in the scenario, trying out strategies to bring the scene to a satisfying resolution. In this way, Boal hoped to create theatre that is a **"rehearsal for life."**

INTERVIEW:
Hai-Ting Chinn, Performer

"Whatever you do, throw yourself completely into it."
Courtesy of Hai-Ting Chinn

American Mezzo-soprano Hai-Ting Chinn is an extraordinary performer who has performed in a variety of musical and theatrical genres. She has been active in Baroque and Classical Opera, Experimental Theatre, and Musical Theatre, and most recently appeared in London's West End Production of The King and I. *Hai-Ting is featured in Philip Glass's and Robert Wilson's iconic production of* Einstein on the Beach *and starred in the Wooster Group's first opera,* La Didone *(music of Francesco Cavalli), an experimental retelling of the Dido and Aeneas story set in and against a sci-fi movie from the 1960s. Hai-Ting is known in New York for being an advocate of classical music in unusual and accessible settings, and she has sung classical opera in a nightclub in Manhattan's West Village and on an active shipping dock on the Brooklyn waterfront. As a resident artist with the HERE Arts Center in NYC, she recently created a hybrid performance piece,* Science Fair, an Evening of Science in Song.

Hai-Ting grew up in northern California and holds degrees from the Eastman and Yale Schools of Music.

I know that you've been a performer since you've been very young. Do you remember your earliest aesthetic experiences? How did you get your start as a performer?

I began when I was four years old. I was put in a children's chorus, and we learned about music; we learned to sing together, and we learned about basic performance aesthetic. We learned to stand in a focused way, and to bow for the applause, and to have a kind of collective performance experience. When I was seven I started Suzuki piano lessons, which has a sort of performance aesthetic where they teach you how to perform while they're teaching you music: to stand next to the piano and bow before you sit down, to take a moment to focus yourself before you start to perform, to give the ending a proper performer's attention, and then to stand up and acknowledge your audience with a bow. Those are very formalized classical and musical aesthetics, but it teaches you that you're not just in relation to the piano or to the song; you're also in relation to the audience. It's important to acknowledge their part in it, and to sort of acknowledge yourself as a person performing the music. I think very early on it taught me the importance of focus in performing, which is something kids don't learn as well in other ways. I think that this kind of interpersonal focus between the performer and the audience is very important to the activity of performing.

When I was seven years old, I auditioned for a community theatre production of *The King and I,* so that was both my first theatre experience and, later, my first professional theatre experience. I really didn't want to audition, but my dad took me to the auditions and said, "We'll just go and see what it's like." So we got to the auditions and we were all in the same room, and I was listening to the other kids sing the songs. And I said, "Okay, Dad, I can do better than that." So I auditioned.

I feel that I really learned a lot from community theater. I feel really fortunate that whoever it was who was running that Light Opera Company had a great way of teaching us all the basics of theatricality. I learned the simplest things: once again, to focus; don't turn your back on the audience; don't upstage yourself; don't upstage other people when someone else is performing; listen to them and give them focus in a generous way; concentrate. The audience is always there, even when you're in the background you're still on the stage and someone is looking at you, so don't fidget. I feel like I'm constantly using the things I learned from this little community theatre company, and they've served me really well in life.

I was in one or two community theatre productions each year from the time I was seven until high school. In high school I did one musical, but in those years I mainly played in bands (concert, marching and jazz bands; I played trombone). I did continue with classical piano until the end of high school. Almost all the music I did was classical, except for band. I never intended to become a professional performer. I thought that I was going to be a writer, a linguist, a translator, an English professor, a scientist, an astronomer, a paleontologist, or an astronaut, depending on the year. [She laughs.]

What did you pursue in college? How did you begin to perform professionally?

I went to college after a year abroad. I lived in France for a year after high school and studied music. I actually had my first classical voice lessons in Paris, with a very old school Italianate-type teacher. I had never been exposed to opera except for the Saturday morning Met broadcasts, and I hated opera growing up. I had the added turn-off that my mom made us clean the house on Saturday mornings with opera on, so I associated it with scrubbing the floors and vacuuming. I didn't like it and had never heard opera live, sung well.

I went to college at the University of Rochester, because they had the Eastman School of Music. I didn't really want to go to Eastman, I just wanted to take lessons on a high level. I was studying linguistics and French literature, and taking lessons at the Eastman School of Music. I soon learned that the Humanities Department there was not what I wanted. It was really a science school, and Eastman was amazing and excellent. I did the second audition to see if I could get in as a voice student at Eastman, and I got in. I continued majoring in English at the University of Rochester and doing the Conservatory degree at Eastman at the same time. I was a double major.

I remember when I got hooked on opera. Someone played me some recordings of Maria Callas, who was the quintessential twentieth century diva. I was amazed by what she was doing! I think the thing about Maria Callas is that she takes the utter artificiality and histrionics of opera and makes it seem like the inevitable way of performing and

acting. The uncomfortable artificiality of opera turns people off. When Maria Callas performs though, she makes it seem like the highest combination of art forms. This is true of a lot of art forms. If you see it done by a master, by someone who's amazing at it, you sense that mastery in a way that if you see it done by anyone lesser it's just puzzling. And I think that Maria Callas did that for me with opera. I became a fan, and I aspired to be able to perform like that.

Did you also receive actor training at Eastman?

The voice degree includes what is pejoratively called "acting for singers." It can be as bad as it sounds, or not, depending on who teaches it. Sometimes they would get acting teachers from the Theatre Department, but not usually. It would usually be people who were hired to teach acting for singers, and so they'd be teaching us sort of Theatre 101. Many singers have this idea that they don't really have to be able to act, or they only have to act while they're singing. This is changing, but in that day and that conservatory environment let's just say the acting was not given its due.

I was in some student-run plays at the University of Rochester, and I was doing theatre on the side while I was learning to sing. I was more interested in it than other people. I feel like I never had a long course of steady training in any kind of performing, but that I just held on to every kernel of information that I could get. I've taken several acting classes since, though.

I had a question about opera. Can you share why you love this art form, and what was its influence on your life?

The reason I love opera is because of its intense artificiality. I feel like if you can find a way of conveying an honest situation or emotion under highly artificialized aesthetic, it can have as much truth and impact as a totally naturalistic production. Like any artificial stagecraft—think about puppetry, or dance, or any of our heightened artificial performance art forms—you can either convey something honest and human through the high artifice, or you can miss it because of the high artifice.

Sometimes the music gets in the way of there being any human conveyance to it. It all depends on the performer, and it all depends on the audience member. Some people are just moved by music, period. I think all art is artificial, and all human action is artificial. You just have to constantly keep trying to convey something honest without telepathy. We don't have telepathy, so we have language and art to make up for that. You have to get around from some other direction the drawing of a buffalo, but you can convey something essential about the buffalo that you might not even notice when you're looking at the real buffalo. Of course I'm thinking of cave art, but when we're thinking that we're capturing the spirit or the essence of something, what we're really capturing is something psychological about what WE see in the thing; and then the person across from us—if they have enough common experience—might have a flash of the same psychological thought because of our representation of it.

And so the artifice, if you use it well, can convey some perfect truth. That's what someone like Maria Callas does for me, or some master of Balinese dance, or one of thousands of thousands of lesser artists who don't always get their work done and it comes across as artificial. Maybe the audience doesn't have enough common experience to get what it is, but I don't think it's the artifice that gets in the way.

What about the Wooster Group? How did you get involved with them? How did your creative process differ when you approached a script with The Wooster Group versus a more traditional type of performance? What did you take away?

It has to be said that what I did with the Wooster Group was an opera. That's how I began working with the Wooster Group. Liz [LeCompte] was commissioned by the Holland and Edinburgh Festivals to do an opera. She had said no several times; she didn't know how to deal with an opera and didn't want to, but the director of the Holland Festival kept insisting. They were having a festival of work by the poet Francesco Busenello, who was a seventeenth century poet. What they wanted Liz to work on was Francesco Cavalli's *La Didone,* which is a Dido and Aeneas story, with the libretto by Busenello.

The way the Wooster Group seems to work, as far as I can tell, is they come up with an idea, or someone imposes an idea on them, and Liz looks at the thing from many different angles, starting with the simplest forms. In this case, she had some music professionals come in. This is early Baroque opera, so it's much more like a play set to music. The Wooster Group brought in some experts and had them teach the Wooster Group actors and crew about this style of opera and its performance practice. They learned about the particular historical stagecraft of the time, and they learned about the instrumentation. The musicians read through some of the opera so they could hear what it was like and they listened to recordings. At some point, when they finally decided they were going to do this, they held auditions. They were looking for singers to see whom they could work with. They didn't know if they were going to have the singers just stand on the stage and sing, if they were going to use a recording, or whether they were going to use the music at all; they had no idea what they were going to do. But they held auditions, and my name was on somebody's list as someone who knew how to do this type of music, because I had been doing some Baroque concert music in the city. I came in and auditioned for them, and I sang off the facsimile score that was handwritten in the seventeenth century. It was written in a different way from modern music, so it was almost impossible to decipher. While I was there, I sang one piece from the show and something else from another show. I sang from Purcell's *Dido and Aeneas,* which is better known, and while I was auditioning they did a bunch of different things with me. They had Kate Valk [an actor with the Wooster Group] stand in front of me while I was singing and translate what I was saying out loud, while I was singing. One of my colleagues who had the same audition described it as, "These actors stood in front of me and yelled at me while I was singing." [She laughs.] That gives you some idea of how this was taken by some of the other singers who auditioned! To me, it was incredibly exciting to have Kate Valk standing in my face and translating what I was saying. I was open to anything, and was really intrigued by

the personalities in the Wooster Group. I didn't know their work before; this was my first experience with them. This was 2004.

It was incredibly exciting! In the end, they ended up with three other singers and me. There were four of us with the regular Wooster Group actors. They work for five hours a day, five days a week, creating a piece together, which I had never done as a musician. I don't think that anyone in opera has ever done that, primarily for budgetary reasons, but also because we just don't work like that. It was much longer than a year. Already, before I started working with them, they had worked on and off for six months to a year with the musicians and with the **libretto**. From the time that I started working it was another two years before we premiered it. We didn't work on it all the time because they went out touring with other pieces.

Liz LeCompte set up rules for games that we were constantly playing, and we had to play three games at once on stage and follow all the rules. For one of them we learned Baroque performance practice, which is highly artificial. It involves standardized gestures for different emotions and different rhetorical devices, and using left and right hands with very particular quadrants and locations. It's almost as stylized as ballet, although a different aesthetic. There's footwork that matches it; when you speak in dialogue with someone you take one step upstage of them, and when you listen you take one step downstage. Apparently a version of this was also used in Shakespeare's day, so there's an Anglicized version of it as well.

We learned the entire opera with perfect Baroque staging. There was also a Mario Bava movie called *Terrore nello Spazio,* which resembles a high fashion space odyssey from the sixties with black leather space suits. There's hardly any plot. It's all style. It's a beautiful slow, crazy movie. The plot has something to do with formless aliens that inhabit the bodies of humans. Somehow Liz LeCompte decided that these two things went together. She put us in silver space suits modeled after the ones in the film, and we became Dido and Aeneas in space. There we were, perfectly performing the Baroque opera within this, and sometimes imitating the Bava film. The mash-up of these two things is quintessential Wooster Group, of two things that become hopefully greater than the sum of their two parts.

For another game, she drew a blue tape line down the center of the stage, and said when you're on this side of the line you're in the movie, and when you're on that side of the line you're in the opera, but you have to keep singing the whole time. They had this whole thing that they do, when they see whatever's on the media on monitors, and they imitate exactly what's happening in the film, including camera cuts and close ups. They have a language of moving on stage that matches the filmic element. We were seeing the Bava film on monitors behind the audience, but the audience was only rarely seeing the film that we were doing.

What an incredible experience! Did this change your creative process?

It invaded my brain like an alien from outer space! Of course it changed my creative process.

First of all, it made me always want to have a collaborative hand in whatever was being done on stage. Liz has all these ideas and she's the final arbiter for what goes onstage,

but those five hours at the Performing Garage are like kindergarten. Everyone's throwing in their ideas. For an entire day we'll spend all our time working on something that somebody came up with, or expanding on a joke that someone makes during the first hour of rehearsal. The next day Liz might say, all right, I'm throwing that all out, it's no good, and we'll go do something else. This incredibly organic process and the desirability of the performer's ideas as part of the show is something that I had never seen before in the opera or in the theater. Ever.

No, it's not often that we get that much time to explore and create a piece like that. Usually we have to get a show up in a defined amount of time.

It's the primacy of the director's vision. Liz doesn't exactly have a vision, she has a playground, a sandbox, and we are her little toys. I think a lot of directors see a vision and they ask you to do it. That's not how Liz works at all. It was an amazing opportunity.

I think it spoiled me for going back to standard opera. I've always had trouble keeping my mouth shut when I have opinions in rehearsal [she laughs], and then going through three years with Liz where she wants your opinions. Sometimes she yells at you for giving them, but she does want your opinions and ideas.

Do you have any advice for a singer who has a different aesthetic? For someone who'd like to perform in many different art forms?

I think that live performance these days has no boundaries, and there are increasingly fewer boundaries between genres. You no longer have to commit yourself to be just one thing or one aesthetic forever and always. That's one thing I find encouraging, at least about New York. I've seen a lot of odd experimental things in Chicago, in Houston.

Whatever you do, throw yourself completely into it. One of the things I learned from the Wooster Group and from Maria Callas is that if you totally commit to something, it comes out better than a more skillful but non-committed person doing something similar. And if it's totally committed and somebody doesn't like it, it's their problem. Right? Not just when you perform, but also when you rehearse. The way the Wooster Group performers were in front of Liz—they would just go all in for, say, a joke that they were making on stage. She would say, "That's brilliant, let's use that."

What other questions would you ask Hai-Ting Chinn if you could?

Do your questions demonstrate __specificity ___polish ___variation ____investment?

SUGGESTED ACTIVITY

Forum Theatre Experience:

- Working in a randomly selected group, discuss scenarios that you might act out for the rest of the class. These scenarios should center on issues in which students are struggling because they lack power or feel as if they lack power.

- Once you settle on a topic, decide which roles each group member will play (yes, everyone should have a role!) and work out a general outline for the scene. Rehearse a few times, and try to anticipate the strategies your classmates might try to resolve the scene. The idea is not to road block them no matter what, but to give a credible reaction to what they are trying to do.

- Show the scene to the rest of the class and have them sub in as "spect-actors" to see if any solutions can be discovered. When other groups are showing their work, take the chance to try out your ideas by stepping into their scenarios.

RECOMMENDED READING

- For some further background on Stanislavski:

 http://www.pbs.org/wnet/americanmasters/database/stanislavsky_c.html

- For another example of a contemporary actor training method that focuses on physical training:

 *http://articles.latimes.com/1985-01-23/entertainment/
 ca-14665_1_suzuki-acting-method*

Forum Theatre Experience – Rehearsal Report

Group: _____ Name of Scene:_____

Brainstorm three different ideas for a scenario involving college students in a situation where there is an imbalance of power. Pick one idea and circle it. Remember to consider simplicity in making your selection!

1.

2.

3.

List each group member's name and the role that they will be performing. Star the names and roles of the person or persons who have power over others and therefore will remain in the improvisation the entire time.

_____ =
_____ =
_____ =
_____ =
_____ =
_____ =
_____ =

Are any props or set pieces required for your scene? If so, what? Draw a picture in the space below. If not, explain how you will convey time and place, etc, without them:

Most of the wording of your scenario will be improvisational, but in scenes of this nature which will be repeated several times, consistency is important! Use the space below to write an outline of the plot of your scenario. Make sure to note entrances and exits and script key lines that indicate a character's action:

What are some things you might encounter when a spect-actor joins your scene? (It isn't possible to anticipate everything, but it is good to be prepared for some outcomes.)

1.

2.

3.

Theatre and Society

> **"** *The word theatre comes from the Greeks.*
> *It means the seeing place. It is the place people*
> *come to see the truth about life and the social situation.* **"**
>
> —Stella Adler

About the speaker:
In your own words:

We have mentioned ancient Greece several times: we have described the relationship of the plays put on to its audience and the conventions of the stage practices, but we haven't talked about who the audience for these performances was and what place they occupied in their society. Plays in ancient Greece were performed in a festival format, with all-day events and a competition for best play. From what we can tell, typical day-to-day Greek life took a break and people arranged their schedules around the performances, almost as if it were a holiday. Can you think of anything that occupies that type of space in our society? For sports fans, it might be the "big games" and the culminating championship; for others, it could be a finale of a show on TV or a premiere of a movie that makes people wait in line for a day . . . but those things are dependent on your particular tastes and aren't part of the fiber of the culture itself. Was there probably some Greek guy who snubbed the festival to stay home and take a nice long bath instead? Probably, but everyone else was at the theatre, hearing the play.

Part of the draw of theatre in ancient Greece was its roots in religious practices. Over time, theatre became more distant from those roots as the culture changed to also become more secular. In the Roman period, theatre was an important part of popular entertainment and not connected to religion in the same way it had been in Greece. When theatre practices emerged again as significant in society, it was back in a religious context with the liturgical drama of the Middle Ages.

A portrait of American actor Edwin Forrest (1806–1872) as Richard III.

© Everett Historical/Shutterstock.com

Poster for an 1899 theatrical production of Harriett Beecher Stowe's *Uncle Tom's Cabin* showing Uncle Tom and Eva reading.

© Everett Historical/Shutterstock.com

In the United States, from the Colonial period through the late nineteenth century, going to see a play by Shakespeare was considered popular entertainment—something average people would do to relax, like go to a bar, take in a variety show, or listen to a concert. The Bowery Boys, rough and tumble residents of the crowded tenements of New York in the 1800s, could recite entire soliloquies by heart! Richard III was a national favorite because of the central figure: the villainous king whose manipulative rise to power and eventual comeuppance probably reaffirmed the swelling national pride of our independent nation in winning its freedom from England and founding a democratic government free from such destructive monarchs. Then, in 1852, something else seized the imaginations of Americans: the epic story of *Uncle Tom's Cabin,* first a novel by Harriet Beecher Stowe and shortly thereafter adapted for the stage. Some Americans were exposed to the story through reading the installments of the novel published in periodicals as it came out; many more saw it first as a piece of theatre. *Uncle Tom's Cabin* chronicles the lives of several slaves and slave-owners in the mid-nineteenth century. One major plot follows a kind, Christian slave by the name of Uncle Tom, another the plight of a slave couple who decides to escape rather than see their young family broken apart. It is a story that humanized the issue of slavery and opened up dialogue as the abolitionist movement gained momentum in the North, and the South dug in its heels to preserve the backbone of its economy. There were many different

adaptations—some that were more political in taking sides on the issue of slavery (there was even an adaptation that was pro-slavery!); some that created a "happy" ending, and some that just contained sketches involving some of the major characters. It would be difficult to find anyone in the United States leading up to the Civil War of 1861–1865 who was not familiar with this story through theatre. When President Lincoln met Harriet Beecher Stowe, he said, "So this is the little lady that started this great big war?" He pointed to just how important this theatrical story had become to the nation. Nowadays, stage melodrama has fallen out of fashion and the once sympathetic characters seem stereotypical, but there were about 50 years of American history in which there would be a performance of the play any given day of the year.

There might not be a contemporary example of theatre having this much of a direct national impact on society in terms of both its values and its laws, but on the local level there are some compelling examples of theatre changing lives—and economies! There is a town in southwest Georgia called Colquitt with a population of around 2,000 people that has been transformed through the influence of arts programs. The cornerstone is an annual community play called "Swamp Gravy" (named after a traditional southern stew) that brings in tourism from across the state and the country. The economy in the town is a very unique pairing of agriculture and the arts as a result. A little over 20 years ago, community leaders got together to try and bring their community back up after a slow decline that had left many empty stores in their town square and a dwindling population. They didn't have much, but what they did have were the oral histories of the long-time residents of the town. Through networking, they found an artistic partner who came to stay in the town and help them build their community through the arts. They began renovations on an empty cotton warehouse near the center of town that became a state of the art theatre; they hired a professional playwright and director and got to work talking to community members about stories they knew that had been passed down from relatives and friends. The stories were turned into a play that is a quilt of monologues, scenes, and songs performed by volunteer members of the community. Over 100 cast members from different churches and different racial backgrounds rehearsed and collaborated to put on the show. It brought together residents that would not otherwise have had a reason to talk to each other, and it was a popular success as well! The group has had former president Jimmy Carter attend a show, and they have been invited to perform across the country. The town now has several restaurants, a hotel, and a marketplace where local crafts and goods are sold—none of which would have existed without theatre's role in their community.

What is the current role of theatre in the United States?

How might that compare to other countries around the world?

MAINSTREAM AND THE AVANT-GARDE

As is true of fashion, cuisine, and leisure activities, what is "in" in theatre and what is "out" are constantly changing. Shakespeare used to be "in," as did *Uncle Tom's Cabin*. Currently, **mainstream theatre** in the United States is often one or more of the following: comedy, domestic drama (realistic characters locked into high stakes conflict that mostly plays out through conversation), and/or musical theatre.

Wherever there is theatre there are always those that work to innovate and change or evolve the art form in some way. We call those productions that push the boundaries "avant-garde." **Avant-Garde** is a French term that literally translates as "advance guard" and means anything experimental and innovative—therefore outside of the norm, or "mainstream." Because neither of these categories is fixed, what happens over time is that trends seen in the avant-garde either become absorbed as part of the mainstream or they die out, leaving room for new experiments to be conducted.

An example of how avant-garde theatre can move into the mainstream can be found in the work of German theatre director and theorist Bertolt Brecht. Brecht started his theatre career in Germany before World War II, where he began to work with an emerging style called Epic Theatre, which hadn't really caught on yet. Epic theatre is designed to incite social change. It desires the audience to intellectualize rather than emotionally process what is happening on stage in order to think critically about the issues presented. This "alienation" of the audience's emotions is achieved through overt theatricality—exposed theatrical instruments, non-literal sets, and the use of projections and songs. Often, scenes will be given titles that forecast the content of the action to follow, so as to do away with dramatic suspense. Brecht also wanted his actors to support this idea by not

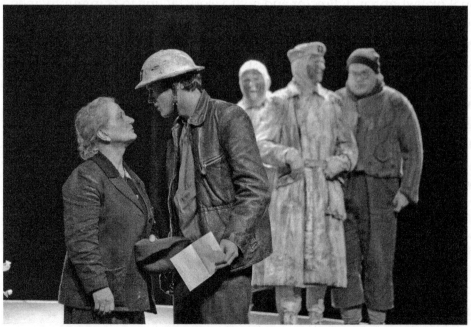

NOVEMBER 26, 2005—BERLIN: Carmen-Maja Antoni, Michael Rothmann a.o. in a scene of the theater play "Mutter Courage und ihre Kinder" (by Bertolt Brecht, director: Claus Peymann), Berliner Ensemble

© 360b/Shutterstock.com

embodying their characters, but playing them in such a way that the audience would be aware that they were watching a performance.

Brecht spent several years in exile during the war and worked in the United States for some years, among other places. When he returned to Germany he founded a theatre company to work in this epic style. Brecht not only wrote for the stage, he wrote ABOUT his choices, sharing many theoretical essays, notebooks that meticulously chronicled rehearsal and production processes, and play texts. Because of this, Brecht influenced many theatre artists who are working today and are considered more mainstream. Think back to the conventions used by the Tectonic Theatre Project in their play, *The Laramie Project.* Having characters indicated by one suggestive costume piece, having a narrator introduce the character, using a minimal set—all of those characteristics are consistent with the performance vocabulary Brecht developed for his experiments in Epic Theatre.

Current avant-garde trends include devised work, non-narrative pieces, and those that incorporate heavy use of advanced technologies applied to a theatrical setting, such as projection mapping, live-feed cameras, and sound manipulation. Already we have seen the adoption of some of these to more mainstream settings. Who knows what the next great experiments will be!

MUSICAL THEATRE

Musical theatre is now mainstream theatre. It is what most U.S. children are first exposed to in their schools and what becomes their standard definition of theatre. Musical theatre has its own set of conventions that are distinct from plays without music. First of all, American musical theatre has evolved to include a complete integration of all elements into the storytelling: music, singing, dancing, dialogue—all serve to not only shape our impressions of the characters but also to advance the plot. Characters fall in love during a song, they have disagreements, and they solve problems while dancing choreography. There are six primary types of songs that occur in a traditional Musical Theatre structure:

1. "I Want" song. These songs lay the foundation for strong character development and help define the immediate motivations for a character at the top of the show, and may change as the plot progresses. "I Am" songs are a close relative to the "I Want" songs and explain a character, group of characters, or a situation.	example:

2. Opening Numbers. These establish musically and lyrically the setting and situations that exist at the beginning, or stasis, of the show, and the way the story is going to be told.	example:
3. Ballads. Usually love songs, but they can also philosophize about any strong emotion.	example:
4. Comedy numbers and Patter songs. Seamlessly blending music with dialogue, these push the plot forward and integrate action songs with dialogue.	example:
5. 11 O'Clock Number - About midway through Act Two there is a point where the conflict is intense and all seems lost for the main character. The 11 O'Clock Number energizes the audience for the final scenes and turns the action toward the climax. (Since curtain times are now earlier, these usually take place around 10:00 pm.)	example:
6. The Finale - The final song packs an emotional wallop, leaving a powerful impression on the audience. Hopefully it sends them out with a memorable tune that will stay with them. Most often it is a reprise of an emotion-packed song that was heard earlier.	example:

Musical Theatre is a uniquely American art form developed from traditions in vaudeville, variety, and minstrel shows (popular forms of entertainment in the early 20th century that involved different acts performing comedic sketches, singing, and dancing routines) and from opera and dance traditions as well. Many writers and producers were searching for a new kind of play with music in the 1920s and '30s, where the music and dancing would push the plot forward and help tell the story. Then, over the years there were a few key productions that marked changes in the evolution of the musical form that we know today:

- *Showboat,* 1927—was the first show to reflect the idea of unity of plot, character, music, and design.

- *Oklahoma!* 1943—at first puzzled the critics because instead of beginning with a large-cast spectacle number, it begins with one man singing alone on stage to communicate the setting of the play. The choreography and integration of this hit ushered in the "golden age of the American musical."

- *West Side Story,* 1957—retold the *Romeo and Juliet* story set in the world of rival gangs in New York City and ended in tragedy. This opened up the door for musicals to address socially relevant subjects in serious ways.

- *Company,* 1970—Instead of being organized around a narrative, this musical's unifying element was its theme. This opened up a new credible possibility for structuring a musical.

- *Hamilton,* 2015—a "rap" musical that unites popular music into traditional musical theatre structure, is an exciting game-changer for its diverse casting, its ability to make history contemporary and relevant, and for its success in creating a new audience for musical theatre. Its creator, Lin-Manuel Miranda, has received multiple awards including a Pulitzer Prize for his work.

Hamilton is a great example of musical theatre that is designed for a commercial model to be performed in a large theater. Not all musical theatre is conceived or designed to be played in a huge theater, however, and we should not think that any musical that doesn't play in a Broadway theater hasn't "made it." An example of musical theatre that has a different mission is the work by the theatre company The Civilians. Their musical, *Gone Missing,* is devised from interviews focused on things that people have lost and found—everything from the usual to the unusual, the literal to the figurative.

POLITICAL THEATRE

Each play has a unique message, but when that message intentionally engages with a political issue—whether it is one that is overtly connected to policy or not—that play can be labeled political. The work of Brecht mentioned in the previous section, as an example of theatrical conventions that moved from the avant-garde to the mainstream over time, is also an example of political theatre. So is *The Exonerated,* which several of our interview subjects for this book have discussed because of its impact on the death penalty in the US. So would *Uncle Tom's Cabin,* which captivated the U.S. for so many years. According to an essay by Michael Kirby published in *The Drama Review* titled "On Political Theatre," political theatre "is a performance that is intentionally concerned with government, that is intentionally engaged in or consciously takes sides in politics."

Political theatre occupies a different role in our society than plays that deal with more social aspects of our human condition. If successful, political theatre changes not only the attitudes of the audience members, but effects policy change as well.

What other examples of political theatre can you discuss?

TRANSLATION AND ADAPTATION

Any play originally written in a different language than the language of the performance must be translated in order to be performed. Translation is more complex that it looks at first glance, because rather than a fixed exchange of one word for another, languages have different structures and grammars, and languages change over time. Words that were used frequently in daily speech even several decades ago are no longer used. Idioms, metaphors, and other figurative speech further complicate things because they are not literal. Additionally, there are issues of cultural translation to address—would this action put into a different cultural context mean the same thing?

This puts a lot of creative decision making in the hands of the translator. He or she will make decisions based on analysis and interpretation of the text just like members of a creative team will do.

For an example, we can turn to the playwright known as the "father of modern drama," Norwegian Henrik Ibsen, who wrote in the late 1800s. His works were quite controversial at the time they premiered. Their style, then an avant-garde trend called Realism that was to cross over into the mainstream, confounded audiences and critics, who were uncomfortable with the complex characters and ambiguous endings.

Over the years, Ibsen's works have been translated into many different languages many times over. Since language and culture are always changing, it is not as if translations just need to be done one time and then they are finished. Ibsen's famous *A Doll's House*, which has been translated into English alone dozens of times, is a great example of this. In *A Doll's House*, Nora, a housewife, comes to the gradual realization that her marriage is a sham, and that she, in fact, has no sense of her own identity because of the way she was raised by her father and then handed off to her husband. At the end of the play, Nora leaves her husband and children in order to discover an authentic sense of self. Initially, the ending was so controversial that Ibsen himself created a revision in which Nora returns to her commitment of the home.

Generally, a translation aims to maintain the intent of the original work, but an **adaptation** is an intentional deviation from the original intent of the piece. It may or not involve translation as part of the process.

A trend in contemporary theatre is in adaptation/deconstruction of classic works, and a recent very successful adaptation of *A Doll's House* was done by Mabou Mines and directed by Lee Breuer. The adaptation is largely faithful to the text in terms of translation, but visually it is done in a very different style than realism.

Realism would dictate that actors be cast largely according to how believable they would be in the roles (remember Stanislavski's assertion that everything in the performance serve this impression of believability), and the elements of the environment of the play would be designed to reflect the accurate setting of the play: the interior of a decent home in a Norwegian town in the latter part of the nineteenth century. The play is still frequently produced according to Ibsen's original intent in this manner, though the setting is now historical rather than contemporary. This allows the audience to better

understand Nora's struggles despite our society being quite different than hers in terms of women's rights and the institution of marriage.

What Mabou Mines did is create a concept in which Nora's stifling environment is physicalized. They did this by casting women over six feet tall to play the three women's roles in the play. They then cast men who were all shorter than 4 feet tall to play the male roles. They then scaled the set of the play to the men, shortening the doorway, furniture, and walls, giving the impression of a doll's house in which Nora must kneel and scoot in order to maneuver.

Compare Mabou Mines' adaptation of *A Doll's House* to a more straightforward film adaptation. What is similar?

What changes are made?

What are the effects of these changes?

INTERVIEW:
Composer/Lyricist/Playwright Adam Overett

"Get to know the musicals you love. Take them apart and understand how each part of the show contributes to the whole."

Adam Overett is a musical theater writer and performer living in New York City. As a composer/ lyricist/librettist, he is the creator of My Life is a Musical; Popesical; Call It Courage *(based on the Newbery Medal-winning book by Armstrong Sperry, nominated for five B. Iden Payne Awards, including Outstanding Original Script and Outstanding Production of Youth Theatre); and many other works.*

As an actor, Adam has appeared on Broadway and on national tour in The Light In the Piazza, Dirty Dancing, *as well as appearing at Primary Stages, Chicago Shakespeare Theatre, the Adirondack Theatre Festival, and the 42nd St. Moon Theatre in San Francisco. He was a Musical Theater Fellow at the Dramatists Guild (2010–2011), a Lucille Lortel Award nominee for his*

contribution to the score of the Off-Broadway musical We The People *(2011), and a two-time Harrington Award winner as a member of both the BMI Advanced Musical Theater Workshop and Librettists Workshop. He has also been a resident writer at the Goodspeed Mercer Colony and CAP21 (2013).*

As a member of the Lehman Engel Musical Theater Advanced Workshop at BMI, Adam won the Jerry Harrington Award for Excellence and is a graduate of Yale University, where he earned a B.A. in dramatic literature and music, and won the John Golden Prize for New Musicals.

Adam, I would love to hear about your process, specifically about the development of new musicals. How do you bring the musical elements into the book and make it work? Where does your creative process start?

It starts with something that will catch my interest and make me ask "What If." For instance, "What If" someone's life is a musical, where people burst into song all around him and only he hears it? What would that be like? What would go on? What would be the problems in that scenario? I'll get tickled by some hypothetical idea or scenario and want to explore it further. It's the same thing with my Popesical musical. What really does go on in there? What would it be like if the papal conclave had these really ridiculous challenges? What if we got a window into their secret workings? What would it be like if the Pope allowed whomever he wanted to be a Cardinal, and a bunch of crazy non-traditional Cardinals showed up to compete for the job? It's usually some spark that comes from the collision of two ideas I've never thought of together before. So it's usually that kind of a funny—or not funny—story question that gets me thinking about what that would be like. Then I go from there and I start working on story first. Just thinking about the characters, discovering what they do and why they do it.

You know, it's the creative process. I always start with story first, before I try to write words, music, lyrics, anything. I may hear a general sound; I was once working on an adaptation of the Russian folk tale of *The Firebird*. In my mind I immediately heard all these fabulous Russian folk sounds, and I intuitively knew that that was what the sound of that world would be. But I don't TRY to make anything yet. I don't try to write tunes or lyrics yet. The musical milieu might show up for me, but I don't try to write anything until I've done lots of thinking about that world and the story and the characters. And a lot of research! It's all about the story. I'm a big believer in that. Everything lives and dies by the story.

I find it challenging to write good material if I don't have the story undergirding it anyway. I find it hard to write if I don't know who these characters are and what they'd say. In fact, usually the way I know that I've done enough story work is that the songs start writing themselves. The characters just start talking and singing, and I'm hearing what's going on. It makes the job a lot easier! [He laughs.] Because it feels like it's inventing itself, it's creating itself.

I do my musical research; I listen to songs and sounds from that world. I'll often think, "Oh, this is a song moment that feels kind of like (and I'll name the song that I already know) that moment from another show, or a piece of a pop song, or a piece of classical music." It's not going to be that, obviously, but it will be something that has a similar

quality. They all do sort of come together in a way, once I've done enough listening and thinking, enough mulling and enough marinating in it. It all starts to come together.

I actually have come to think of it—I'll tell myself this on days when I don't feel like writing—that all I'm really doing is just LISTENING to it. All I'm really doing is just sitting down and just LISTENING to my show for a half hour. I don't have to come up with anything, I just have to sit down and LISTEN to the characters and to the story, and just let it be there for me. And invariably, if I'm just sort of getting out of the way of it, things will happen. So, as opposed to trying to force something out, I'll just say, "What is going on here? Let me just read the last few pages of what I wrote, let me just sit and listen to what the story is right now. I just have to pay attention to it." And that's when I'll get an idea and start to discover it, the way hopefully the characters themselves start to discover things along the way.

No one really knows how this all happens, it just sort of takes shape. It's hard to really put a pin on how things happen.

I know you had training in learning how to write musicals. Where did you learn? I believe you were in the BMI Workshop and Cap 21?

Yes, I did the BMI Workshop, and Cap 21 gave me some space for free for a while. It was like a residency where some other writers and I could talk shop in the kitchen. BMI was more actual training.

I doubled in music and literature in college—I knew what I wanted to do. There I did a lot of serious history composition, a lot of performance as an actor and singer, a lot of reading of plays.

Why does musical theatre resonate with you so much? What, for you, are the primary features musicals have that traditional plays don't have? Why are musicals so appealing to you?

There is a power in music, in that organization of sound, a creation of tension and release, which has a magical quality for us human beings somehow, and always has. Throughout history music has always been connected with things that are sacred. A lot of it comes from religious traditions, with our trying to connect with something that's on a deeper or a higher level, beyond the plane of ordinary existence. I love the use of that in telling stories. I love that a musical is an art form of storytelling that harnesses that kind of magical power. There is something wonderful in using both speech and the particular organization of sound that a song is. People who are speaking—you get that sort of naturalism—but then, you have something that is organized, like a SONG. I love that there is a difference in the heightening of the storytelling between the spoken word and music. When you heighten a story with this power, it creates something that is utterly transcendent. Musicals explore this. They explore the in and the out of that. Plays tend to remain in that universe, and operas tend to remain in that other universe. Musicals like to go back and forth, and I love that. When it's done well, I feel it can lift you out of your seat.

What advice would you give to any aspiring writers/composers/lyricists who want to write a successful musical?

Get to know the musicals you love. Get to know them well. Listen to them a lot, and read them and pay attention to them. Take them apart and understand how each part of the show contributes to the whole, and to the protagonist's central journey. Musicals are very tricky beasts and writing one has everything to do with the structure, so you're kind of learning your architectural skills by studying the great musicals and, most importantly, learning the ones that really speak to you. I'm a big believer in following your bliss, when it comes to artistic pursuits. Pay attention to the things that you really love, not what everyone says you should love, but what you really love. And think about why; figure out how people built the musicals you love.

In terms of actually writing a musical, I begin with story and I think that's a great idea, but more important than that is the idea of knowing that writing is a long and difficult process. I am a believer in consistency and discipline and diligence when it comes to working on something like this. Musicals usually take a long time to create, but I think it's good to stay in touch with first impulses, what first drew you to your show idea, and if you work consistently, that will help. I feel that you want to try to put in some time every day in making a musical, even if it's just listening like I was saying before. I've gained so much myself as a writer from forcing on myself the discipline of writing every day. It makes a big change. And it makes your work happen. It makes you make stuff.

Those are the big points. Get to know the things that you love, putting in the time and paying attention to your work, and allowing yourself to be surprised by what you write. Let your characters run off and do the things that you didn't plan for them to do! I like to make plans for my characters, and then I love to set them on their way; and invariably they will do something other than what I planned, and it's better. It's usually better and more interesting. I'm a big believer in both planning and flexibility when it comes to crafting a show.

I also would say that I think a lot of people get concerned with having their own artistic "voice," and I feel that's best left to your own natural growth and maturity instead of trying to make that happen. I feel like if you're a young artist the best thing you can do is to try to tell your story in the best, most exciting way that you know how to do, and let your voice take care of itself. And probably when you're just starting out you will sound like the people you admire. That's fine! As you continue to work, people will start saying, "Oh, that sounds like you." "That's so YOU, that song," or "That's your thing to do." People will tell me that sometimes, and I'll say, "Oh you're kidding, I didn't know that I had a thing that sounds like ME." To me it sounds like that character, or it sounds like that other song I think it's similar to. So, I feel that trying to force a voice out of yourself is kind of counterproductive. It can lead to being dishonest in your work, doing things you don't really believe because you're trying to sound different or sound like something other than who you really are.

You're going to get your most authentic work when you do things that YOU think sound great, like something YOU would want to go see. And through that process, by

being as authentic as you can be, your own voice is bound to come out. It has to. There's no other way.

I write every single day. I read a quote by Jerry Seinfeld, who I'm sure got it from somewhere else in turn. He said that starting out he would make sure he wrote at least one joke every day. When he had written his joke he'd put an "x" on his calendar for that day. After awhile he built up a chain of "x's" and the goal was to never break the chain. He wanted to make a chain of x's, meaning he'd write something every day. And if you miss a day, you mess up, just make a new chain. But the idea of somehow recognizing that you are building a new habit for yourself and you are crossing those x's off every day can be very empowering and very self-fulfilling. I've been doing that now for years. I won't miss a day. I write for at least a half hour a day, even if it's just listening to my characters, like I said. And I just make sure that I put in some of that time every day. I recommend that very, very highly. Because then you're a WRITER; you're doing it.

It's very easy for us writers to say, "Oh, I'll figure that out when I have time," or "I'm really busy, I'll get to it." Or "I'm not inspired right now, so I'm not going to write today." Those are traps. They keep you from writing. They play into a voice in your head that says, "Oh, you're unproductive. You're procrastinating. You're never getting anything done." It's an inner critic that can keep your work from flourishing.

But if you say, "No. Every day I'm going to write something, even if it's crap. I don't care if it's crap." There are many, many of those days that nothing happens but crap! That's all right, it was a day. And so I'm a big believer in putting in the time, carving out the time and making it happen even when you don't feel like it. And making a routine out of it is even better. If you have a time of day or place that you always go to, it's great. I really believe in that.

What other questions would you ask Adam Overett if you could?

Do your questions demonstrate __specificity ___polish ___variation ____investment?

INTERVIEW:
Dramaturg Ken Cerniglia

"With theater we're developing the citizens of the future."

Ken Cerniglia is dramaturg and literary manager for Disney Theatrical Group, where since 2003 he has developed over fifty shows for professional, amateur and school productions, including The Hunchback of Notre Dame, Aladdin, Peter and the Starcatcher, Newsies, The Little Mermaid, High School Musical *and* Tarzan. *He has adapted Broadway scripts for young performers, including* Beauty and the Beast JR., The Little Mermaid JR., The Lion King JR. *and* The Lion King KIDS. *Recent freelance dramaturgy credits include Chris Brubeck's symphonic play* The Cricket in Times Square *and* The Gift of Nothing *(Kennedy Center), the documentary play* ReEntry *(Two River), and* Bridges *(Berkeley Playhouse). Ken is resident dramaturg for Seattle's Fisher Ensemble and artistic director of Two Turns Theatre Company, which produces intimate theater in unique places. He holds a Ph.D. in theater history and criticism from the University of Washington, has published several articles and book chapters, and recently edited* Peter and the Starcatcher: The Annotated Broadway Play *(2012) and* Newsies: Stories of the Unlikely Broadway Hit *(2013). Ken is a co-founder of the American Theatre Archive Project, which supports theater makers in archiving records of their work for the benefit of artists, scholars, patrons and the public.*

Most people don't know what a dramaturg is. As the Dramaturg and Literary Manager of Disney Theatrical Group, what are some of your responsibilities? What exactly does a dramaturg do?

Well, as a dramaturg I work in the Creative Development Department. When there's a new show that Disney is developing, I'm usually part of it from the ground floor, especially if any research needs to be done. I start the conversation, asking what are we trying to do? What's the goal of the project? I'm also a responder and editor in development, from the pitch phase through treatment, through outline, table reads, getting actors involved, trying to make the show the best it can be. I'm one of a handful of people who has input along the way to developing a new show.

What type of show do you typically work on?

It can be a show for almost anywhere. We develop shows for elementary and middle schools, shows that go to Broadway, shows that we co-produce with regional theaters. We create shows that we license for other people to produce; we produce shows ourselves on Broadway, and we often co-produce shows abroad with international partners. If we have a new title that we think has potential, we have a lot of avenues for the distribution of it. Keeping who's going to be doing the show in mind is a big part of development. Obviously, we think long term and where eventually we want this show to go, what will it be like, in what form. A show is often re-developed for different destinations during its lifetime.

So you're involved every step of the way?

Yes, from soup to nuts. I'm also usually the last one on the development team to touch a show, because I manage the publication process for the licensing catalog.

Since we've been discussing the aesthetic experience and creative process, I'd love for you to share your process of how you create shows. You've developed High School Musical, The Little Mermaid, Beauty and the Beast Jr., Camp Rock, Newsies, *and* Peter and the Starcatcher *for professional, amateur and school productions. How do you start to work on your concept, and then what are your general goals?*

Once we identify a title that we might want to produce, publish, or develop, we have to ask, "Is it stage worthy?" We have a lot of shows in the Disney catalogue that we look to develop. Either the idea is ours and we go outside for writers and directors, or the idea comes from outside and is pitched to us. Essentially it comes down to two things. The first is what can be added to the source material if we develop it for the stage? If there's something fantastic on film, or in another medium, what's the added value for the stage? What's the theatrical idea? It may not have one. It may be completely film-bound, in which case it probably isn't going to be developed for the stage.

The other thing that we look for, because we mainly produce musicals, is does it sing? How can musical theater enhance the storytelling?

So, you only develop musicals?

Not only musical theater, ever since we developed *Peter and the Starcatcher.* That was new for us in three ways: (1) we developed it with regional theaters, and (2) it was not previously dramatized. We didn't have it from a play, or a movie, or a TV show. And, finally, (3) it didn't become a musical. It was a play, it had some songs in it, but it was a play. Now, whenever we develop a show, it doesn't necessarily have to become a musical. We developed *Shakespeare in Love* for the stage, and that ended up just being a play.

How do you do this, exactly? Is there a story or example that you can share to illustrate more of your creative process?

High School Musical was interesting because when that came out we had just started developing hour-long shows for middle schools and half-hour shows for elementary schools. Music Theater International had been, for about eight years, "juniorizing" or cutting down Broadway shows for middle schools. At one point they did a survey of which Broadway musicals people wanted to do in middle schools, and a lot of the titles near the top were Disney animated films. So MTI asked us if we would be interested in developing musicals for schools that hadn't been developed for Broadway. We were intrigued and decided to take a whack at it.

We did *Aladdin* first, long before we had the Broadway show. We did an *Aladdin JR.*, and then we did three half-hour shows, which were part of the new KIDS series: *Cinderella KIDS, 101 Dalmatians KIDS,* and *The Jungle Book KIDS.* After those had been out on the market a couple of years we heard that the Disney Channel had a new TV movie called *High School Musical.* We thought, wait a second—we're doing musicals in schools; besides the JR. and KIDS shows, high schools had been doing the Broadway version of *Beauty and the Beast* and a slightly edited version of Elton John and Tim Rice's *AIDA.* So we were very interested in *High School Musical.* After we saw an early cut, before it premiered on TV in January 2006, we were able to get the rights to develop a stage version for high schools and put it into development very quickly.

The movie and soundtrack were already a huge pop culture phenomenon, and everyone who was twelve and under knew about it as well as anyone in their circle. Although we were rushing a bit, we were determined not to sacrifice quality. We redid some of the songs, and adjusted some of the characters, but basically followed the overall plot of the movie. We injected a couple of new songs and theatricalized all of the pop songs, because you can do a pop song in a TV movie and direct it like a music video, but that doesn't make it musical theater. We really had to look at each of those songs and come up with dramatic action, things for actors to play to use the songs on stage. I thought we did a pretty good job!

We did a reading in June of that year, and it worked. We laid out the libretto and music, recorded it, and put it into the MTI catalogue in the fall of 2006 for high schools. But soon we even had interest from professional theaters that wanted to license the show. We decided to allow five professional theaters to try it out. One of them, Theatre of the Stars in Atlanta, hired a Broadway director, and they turned out a pretty good production.

It premiered in January 2007, and it was so successful that we decided to send it out on tour as a Disney Theatrical production. We also contacted the high schools that had done the show along the tour route, and invited the students to be a part of the basketball crowd at the end of the show. It was a pretty cool idea. It was a company-management nightmare to coordinate, but it was a great experience for those kids.

It was *High School Musical* and then later *Peter and the Starcatcher* that really shook up what we had expected for our division, because here we saw many more ways to be able to bring theater and musical theater to new places in different ways. We had been focused on traditional Broadway shows that were developed, played out of town, came to Broadway, went international, and then eventually got licensed. That was the model, that progression of development. Now, anything goes. A project can start and we think it may go one way, then all of a sudden an opportunity opens up and it can go another way.

My role as a dramaturg on *High School Musical* was working with the book writer and music adapter, taking the source material, the screenplay, and these pop songs written by a whole variety of artists, and trying to put them together in a stage worthy way. It takes a certain kind of investment and attention to watch a two-hour TV movie and a completely different level of attention and commitment to rehearse and perform a stage play. We didn't want schools to get the material and perhaps feel that the musical was a derivative from the TV movie. With the adaptation, we took it to the next level. *High School Musical* was so popular, the title alone would appeal to licensees, but that's not how we do things. We're quality first; we don't cut corners anywhere. We really pushed the envelope in development, although it was rushed, and I kept pushing it as dramaturg too, until the show was the best we could possibly get it to be.

We always read a show at a table first, just with staff, even before we get the actors involved. We want to make sure something's working on the page. When we get feedback from our producers and others, we'll have to incorporate that. Sometimes we do a table reading and realize the show doesn't work at all. We become acutely aware of it and have to go back to the drawing board. A lot of times we actually have to pull the show apart and put it up beat-by-beat, song-by-song, action-by-action, on a board so we can look at it visually. We inherited this way of working a little bit from animation, because Disney Theatricals grew out of Disney Animation. That's the dramaturgical process over there, throwing a whole movie up on a storyboard frame by frame to look at the whole thing and to see how all the parts fit together. For musical theatre, we look at where songs sit, look at the character arcs and how they all fit together. Musical theater in particular is hard to get right and it's easy to get wrong. A play can have a whole multitude of structures and ways in, but in musical theater there are far fewer structures and plots and frames that can work. It's not just the dramaturgical structure that has to be sound, but also the score structure. How does a song function individually and within a score? You're going to have to know the plot. It's an organic thing, a beast; it's just really hard to do.

I'm involved in the whole imagination process, the development process, and then in getting it in front of an audience. I always watch the audience; the audience always teaches you something new. You think it works one way or something is funny, and then you go in front of an audience and they tell you something different.

You're so involved in getting young people involved in theater through the shows that you do. I've heard you say that theater is good for kids; I know that's true, but I'd love to get your thoughts.

Theater is good for kids, for the very things that you learn when you produce a show. It's not just sitting down in front of your screen for a couple of hours and watching a movie; it's actually playing a part, whether on stage or back stage. Designing, managing, performing, any of those things, is great experience. Just learning to be part of a team. You also learn that theater is a production. You have to have planning; you have to put on the event. It's not just the play; it's everything leading up to the play.

I think it's good for kids to be part of a team, like sports only more complex. Everyone plays a part and puts something up in front of the audience. I've seen kids really transformed by being part of a theater production. On the performing level, it develops reading literacy and music literacy. The big thing, of course, is learning empathy, because in the twenty-first century you have so many opportunities to have your own individual entertainment, through your own screen, your own Internet. Theater brings kids together in a live way and gets them to cooperate. It's not just putting a show up but exploring the lives of characters through fiction, actively in a live way. I've seen kids with psychological obstacles who learned how to work through them by playing a character. Acting allowed them to step aside from themselves. They could pursue a human character arc, but not necessarily their own, and unlock those obstacles they found in their own lives. In our outreach program, Disney Musicals in Schools, we've worked with special needs populations where the kids don't get any access to musical theater, and these shows help them in an awesome way; not just in acting them but in being responsible to their classmates and showing up on time. It was important for them to come to rehearsal because it wasn't just their experience but everyone else's as well. You have to follow through because everyone's counting on you. Kids are getting that in a way they've never got it before, even if they play sports or some other activity. In sports, sometimes kids can just not show up because they don't want to play, then the coach just puts in another player on the spot. But in theater you really do have to be there everyday. Some kids have never had any kind of experience like this before, and really grow in surprising ways. They develop a sense of responsibility and pride to work so hard for so long, and then to have an audience come and hear their words and cheer them on is just transformative. With theater we're developing the citizens of the future.

Do you have a personal aesthetic or mission that guides your work?

My personal aesthetic is the question that I ask of all my collaborators, which is "Where's the welcome?" What are we trying to do, and where's the welcome in our show? I realize that not every show is for every person, but I have been working for Disney for twelve years and part of what we're trying to do is to develop a wide audience and be welcoming. I think about that, and dramaturgically speaking 'where's the welcome' begins before you get into the performance space. What do people know about the show? Is the invitation open or is it closed? What do people know about it coming in, and then once they're in, what do we do in our show to provide what is welcoming to them? Where are we inviting

people to lean in and participate actively? Part of my aesthetic, too, is that I want audiences to be welcomed, to lean forward, instead of being blasted back into their seats. I think there's enough in pop culture to give us that if you want it. I think that theater can provide what no other entertainment form can provide—the chance for us to collectively lean forward and listen and imagine. That's where the welcome is in what we're doing, so people can have the chance individually and collectively to lean in and listen, and invest in the time that we have together.

Absolutely! That's what live entertainment does.

Yes, it's live, but it's also collective. I'm aware that we all have opportunities to be entertained individually; where do people collect anymore to have a shared experience? If they're religious, then there's some sort of religious service; if they're sports fans, that's a collective experience. Then there's theater. People don't go to movies as much anymore; they don't watch television together. Concerts and theaters, that's the live event. Concerts, performing arts, and theater—the live performance event. That's it right now, where you can have a collective experience. I think it's becoming more vital right now for the future, to have places where people can have a shared experience in our world.

Are there any shows you are particularly proud of?

I love all my babies, but I have a special place in my heart for *Peter and the Starcatcher*, because we were doing something new on so many different levels. Also, it's special because I was intimately involved in the development from the beginning. I was working on it with the two directors even before we had a writer. In terms of shaping it, visions for the stage, I had a hand in all of it. We were just trying it out; we didn't know where it would go. To have gone to Broadway, that was never in the cards, it just happened. That was amazing. Nine Tony nominations, and it won five, probably the only play to ever win four design awards. It was a great experience. Theaters are now licensing it all over. The Shaw Festival is doing it now. I love seeing how other people produce it. It's like letting your kid grow up and be her own self, and smiling with pride because you had a hand in that success. That's how I feel as a dramaturg. I'm here to nurture and support artists to make the best theater possible. When it works, there's nothing better!

What other questions would you ask Ken Cerniglia if you could?

Do your questions demonstrate __specificity ___polish ___variation ____investment?

SUGGESTED ACTIVITY

- Work in groups to outline a musical version of a well-known fairy tale. Come up with ideas for each of the six types of songs. See if you can title the songs and place them in the narrative to enhance the storytelling.

RECOMMENDED READING AND VIEWING

- The *Civilians Gone Missing*

 http://www.thecivilians.org/past_shows/gone_missing.html

- Ibsen's *A Dolls House*—full text available online

- Ibsen's *A Dolls House*—film version available through YouTube

 https://www.youtube.com/watch?v=m81oiq5yvCc&list=PL5099CFB2656B41F9

- Mabou Mines' *A Dolls House*—recording available through

 http://search.alexanderstreet.com/music-performing-arts/view/work/1780005?play=1
 (see if your library subscribes for access)

- A review of Mabou Mines' adaptation of *A Dolls House* by Henrik Ibsen

 http://www.maboumines.org/press/curtainup-review-mabou-mines-dollhouse

Defining Your Personal Aesthetic

"*I believe theater artists should be students of humanity.***"**

—Taylor Mac

N ow that you have sampled all of the theatrical offerings at our buffet, it is time to decide what you would like to go back for more of, and/or what you would like to invent for the future of theatre as an art form. We have looked at what we consider "conventional" theatre, and also those models that are more out of the norm, recognizing that what is considered mainstream is constantly, incrementally changing. It has always been our intention to present these different ways of creating and performing theatre without bias, so that you would now be free to decide for yourself what your ideal theatre experience looks like.

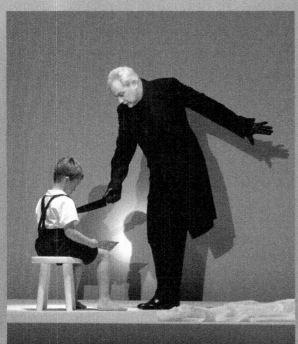

**AUGUST 30, 2006—BERLIN: Robert Wilson with others during a rehearsal of the opera play "The Murder from "Deafman Glance,"
Staatsoper Unter den Linden, Berlin.**
© 360b/Shutterstock.com

At this point, it is helpful to review the examples of theatre we have explored throughout the semester and classify them according to loose continuums. There are trends in theatre-making, or process, we can categorize, and likewise trends in the characteristics of the performance, or product. For the purposes of this introductory course, we are defining conventional theatre-making as those characteristics of the current dominant trend in the creative process.

Theatre-Making: PROCESS

	CONVENTIONAL	ALTERNATIVE
Characteristics	a) A single playwright creates a script, b) That is then turned over to a creative team, c) Which is organized in a hierarchy with the director at the center of the artistic process. d) Actors are cast for the production and a finite rehearsal period is given to getting the show ready before it is performed before an audience.	a) May not have a previously extant script, such as in devised work, improvisational theatre, or non-text based theatre b) Writers/creators may remain part of the creative process throughout the rehearsal period c) May involve a collaborative structure that is more collective than hierarchical d) May be developed over a longer period of time and with different constraints
Advantages	a) Having a hierarchical structure with the director at the head of the creative work is a good way to make sure that the choices being made lead to a cohesive product. b) Having an existing script (especially one that has been produced before) makes the condensed rehearsal periods able to focus more on the actors and their work.	a) Often the best way to create innovative work b) More flexible and fluid c) Shared responsibility
Disadvantages		

There is nothing inherently more challenging about an alternative product, other than its lack of familiarity to a broad audience base. To extend the buffet metaphor, if a conventional product is a classic, delicious steak, an alternative product might be something like sushi. If you eat sushi and you are expecting steak, you are in for quite a shock. But if you enter into the experience with an open mind, you might find something deliciously enchanting there as well!

A process may be more or less typical depending on its unique set of characteristics; likewise for a performance product. Also, there is a relationship but no definitive correlation between the way something is put together and the way it looks in front of an audience.

Theatre in Performance: PRODUCT

	CONVENTIONAL	ALTERNATIVE
Characteristics	a) Narrative-driven b) Proscenium configuration c) Fourth wall observed d) Approximates reality in its look and feel	a) Organized by theme or other non-narrative means b) Immersive c) Interactive d) More abstraction in the environment
Advantages	a) Everyone in the audience has a similar experience b) So you can create illusion c) Can either enforce or challenge the status quo	a) Conveys a deeper than literal truth b) Experience new ways of creating environment, audience expectations, etc.
Disadvantages		

Here are some examples, some of which you should be familiar with from our studies:

1. **Conventional Theatre-Making and a Conventional Performance**

 This is the most common model. *Doubt* fits into this category. How the play is made generally will follow the personnel hierarchy and the look and feel of the production will match the expectation of how a linear narrative would be presented. Surprises lie within the subtle variation in performance and the environment evokes a sense of actual space and time to which an audience can easily relate.

2. **Conventional Theatre-Making and a Alternative Performance**

 A good example of this model is theatrical work produced by American experimental director Robert Wilson. His most famous work is *Einstein on the Beach* and it does not have any narrative. It is also five and a half hours long and the audience is free to move in and out of the theatre during the performance. Wilson was a visual artist before he became a theater director. As a result, his productions have a look and feel that are highly aestheticized. He is very interested in putting simple shapes and lines together to create an abstract environment that evokes atmosphere rather than a sense of actual space and time. The

performance by the actors is also heightened; they often perform the lines in a presentational mode (i.e., facing the audience instead of facing each other when they are in a scene), and their faces are painted white.

However, in terms of process, all of Robert Wilson's production follows the conventional hierarchy.

3. Alternative Theatre-Making and a Conventional Performance

For this model, *The Laramie Project* is a good example. It had a very unusual production and creation process in which Moisés Kaufman and the members of Tectonic Theatre Project started by interviewing people from the community of Laramie, Wyoming, in the aftermath of the murder of Matthew Shepard. They then put the interviews and their personal journals together to construct a script and together they built the production. In this devised theatre, the starting point is not an already written play.

Although Moisés Kaufman was the director and the one who started the idea, he was also part of the *ensemble.* Since an ensemble is made up of a group of actors and/or performers and/or directors and/or designers who each has equal say in the process of creating theatre, the standard hierarchy was not followed.

Although *The Laramie Project* went through an alternative producing process, the look and feel of the production was within the expectation of how a linear narrative would be presented. Surprises lie within the subtle variation in performance and the environment evokes a sense of actual space and time to which an audience can easily relate.

4. Alternative Theatre-Making and a Alternative Performance

This is the least common of all the models. A good example is an ensemble-based collective from Austin, Texas, called the *Rude Mechanicals.* They have been creating new and original work since 1995 through devising. Overall their process has a fluidity to it because they start every process by gathering their ensemble members together to tackle writing, designing, building, and performing together. Their works varies wildly in content and in aesthetics, although humor is a very vital part. The company drew the following diagram to illustrate their process in creating *The Method Gun,* which investigated the life and techniques of the actor-training guru, Stella Burden, during the 1960s and '70s. Using this as a jumping off point, the production also discussed self-actualization in everyday life.

As you move forward in creating theatre, you might find one particular model better suited to supporting your concept, but also do not be afraid to combine them. These models are presented as guidelines, but in reality the line between them is very fluid, and even within one production, the model can shift as needed.

© Thomas Graves

What other examples can you come up with for conventional and alternative practices and performances?

WRITING WHAT YOU BELIEVE ABOUT THEATRE

The following are excerpts from a speech given by contemporary theatre artist Taylor Mac at the 2013 Under the Radar Symposium. The symposium is part of the Under the Radar Festival, an annual event at The Public Theatre, a non-profit, Off-Broadway theatre. The Public Theatre is a prolific organization, producing free theatre in Central Park, as well as a balance of classic and new works in their several theatre spaces. Over the past decade or so, the Under the Radar Festival has become an important part of their season, exploring new works and new directions in theatre. To date, they have hosted 181 companies from 39 different countries. One of their distinguished presenters in the past was Gob Squad, whom you might remember from its mention in the previous chapter.

Taylor Mac (who uses "judy," lowercase sic, not as a name but as a gender pronoun) is a playwright, actor, singer-songwriter, cabaret performer, performance artist, director, and producer. In a 2008 interview with Caridad Svich published in *American Theatre* magazine, Svich describes Taylor Mac's work as engaging "in fierce political and personal explorations of theatrical excess, specifically exemplified by drag artists and playwrights working in the realm of camp during the 1970s." Mac is a self-described pastiche or collage artist, who works by layering established forms of performance into new combinations. At the center of Mac's work is Mac's own body—which judy simultaneously masks and exposes through the use of stylized make up, wigs, and costumes specific to each performance work. Taylor Mac has performed as part of the Under the Radar Festival in the past, and was invited to be one of the keynote speakers of the symposium associated with the festival.

We also encourage you to watch Mac deliver this speech in its entirety through his website: www.taylormac.net.

———◆———

I believe that truth, in the theater, is often confused with a clearing away of theatricality. I believe the clearing away of theatricality is as much of a glorious lie as the theatrical. I believe homophobia, racism, and sexism (in the theater) often manifests itself through the championing of "Realism" and or "Quiet" plays.

———◆———

I believe, as a theater artist, I'm not telling you anything you don't already know. Because I believe, as a theater artist, I'm not a teacher; I'm a reminder. I'm just trying to remind you of things you've dismissed, forgotten, or buried.

I believe self-consciousness kills creativity. So we must work together to create environments where we can kill self-consciousness first. Make your rehearsal room a place that kills self-consciousness. Ask yourself, "Will these florescent lights kill self-consciousness?" No? Then light the rehearsal room with pleasant lighting already.

I believe designers should be in the room every day, playing, not just sitting and taking notes. I believe we must give our designers things to play with in the room. I believe designers and even stage managers should do warm ups with the company.

I believe love when used as a verb is true and when used as a noun is a lie.

I believe you can make a living as a theater artist but in order to do so, without making work you don't like, you might need to think about falling in love with verbs more than nouns.

I believe money is never really the reason but often the excuse. So when you say you can't do my play because it will cost too much, I know what you really mean is, "I'd rather spend the money that I have on something else." I believe that's fair.

I believe theater is a service industry. It's like being a plumber and theater artists are blue-collar workers who wear better clothes, for the most part.

I believe theater artists should be students of humanity.

I believe, to learn what your audience needs, is the job but caution that sometimes we confuse need with want. Giving our audiences what they want is not the job. Sometimes giving them what they want is a fringe benefit or happy accident but it is not the job. I believe you may be saying to yourself, "That's very presumptuous of him to think he knows what the audience needs," but I believe if I were a plumber you wouldn't think it was presumptuous of me to say my job is to learn what your plumbing needs. You would say I was a good plumber.

Notice that Mac uses the effective repetitious structure of beginning each statement about what judy believes about theatre in the same way. Mac also uses plain, unqualified language to clearly state beliefs, some of which are hopes or dreams for the future of theatre as well.

SKILLS FOCUS:
Manifestos and Personal Statements

In order to help you crystalize your thinking, you are invited to create your own version of a manifesto, or personal statement, that describes both defining moments for you in terms of what type of theatre you respond to and what you feel is ideal.

It may be helpful to begin by brainstorming, using Taylor Mac's structure as inspiration. Take a moment to write down "I believe . . ." on every other line on a piece of paper or a Word document. Then, put three minutes on the clock and think about what comes to mind when you think about powerful, evocative, effective theatre. See what you can come up with, challenging yourself to keep writing, even if you think you don't have anything to say.

Use the space below to write down your "I believe..." brainstorm:

Then, consider the following prompts to shape a story of your personal relationship to theatre:

- Taking into account your experiences in this class and out, what does theatre mean to you?

- How has your understanding or appreciation of the art form changed over time?

- Describe the most impactful aesthetic experience you have had with theatre.

See if you can incorporate examples and vocabulary from this course into your statement, and make sure to use clear, unqualified language to confidently express your opinion.

Here are what some Introduction to Theatre students had to say when asked to define their personal aesthetic. As you read their statements, UNDERLINE their use of confident language, and put a BOX around where you see them integrating concepts and vocabulary from the course.

——————◆——————

I was never able to appreciate theatre the way I do now. I was always guided by the misconception that theatre was just for a specific group of people and such group was already glued to my mind. I used to think of theatre as an art that can only be understood and appreciated by older and boring people. I never thought that theatre was something interesting and enjoyable. In my mind, theatre was something I could never find a connection with. It was just something boring and too formal. But, after having acquired some knowledge regarding theatre and being exposed to it while exploring it in a different way, I have realized that theatre is more than what I thought. I realized that in reality theatre was not what I thought. Theatre is not boring as I used to think. It is even more engaging than movies and films, and it is in "the now." It is in the moment. Theatre represents reality, the present. It doesn't have to be perfect, because no one alive is and theatre is not dead, theatre is also alive.—Daianne Ortiz, sophomore, undeclared major

——————◆——————

When we watched clips of Robert Wilson's productions, I felt like he was able to use a type of expressional movement, lighting, and visualization as an art that spoke as loud as words. Although it was much less straightforward, it gave me more freedom to make

my own decisions of what he was presenting. I enjoyed this idea of letting the audience make up the message for themselves, because sometimes it may be more helpful than giving it to them directly. The freedom of the body and the mind to explore the aesthetic setting enlightened me. This was completely different than my experiences with watching conventional musicals and plays such as Bike America, Wicked and In the Heights. Instead of my brain wandering in endless directions, the lyrics and the tone of the actor's voices allowed me to understand different themes and messages the director wanted me to pick up on.

The journeys that these two types of theatre lead me on have impacted me in different ways, and each aesthetic experience has allowed me to better understand theatre's role in my life.—Chelsea Garcia, sophomore, biochemistry major

My appreciation for theater has also changed as I've grown up. When I was younger, I mostly saw plays like *The Lion King,* or other suitable children's plays where I knew the plot going in. As I've aged, the plays I've seen have been less narrative occasionally, and often I have no idea of the storyline (if there is one) going into the performance. This has generally enhanced my appreciation for theater. I used to think that the performances were a bit boring because they were predictable, but now I know that's not the case with most plays. I've also become more open to new and different types of theater from taking this class. For example, the Robert Wilson pieces we watched in class, such as *Einstein on the Beach,* really intrigued me. He was never someone I heard of before this class, and if I had seen the video of the performance before taking this class I probably wouldn't have been interested in seeing it live. However, now, it would be a wonderful experience to see one of his plays performed live. Furthermore, I had never heard of forum theater before this class, but I would love to be able to experience something like that where audience members become actor—the "spect-actor" as discussed in class. It would be interesting, especially since in this type of theater, it is usually members of a community becoming the actors, and it would be fun to watch my peers do this.—Gayle Geschwind, physics and math major

It may also be helpful to think about how your ideal experience would be created if you had all of the resources needed to create your own theatre company.

Due to how I personally prefer to view theatre, my theatre troupe would most often perform on a proscenium style stage, occasionally flirting with a thrust stage construction. Almost never would my troupe perform an immersive piece or on a stage with arena seating. My personal views on art include the fact that it is supposed to be viewed, not physically interacted with—in my view, interaction with art happens in your head, or with conversations with others, where you consider the piece, its ramifications, and its subtexts. A proscenium stage construction is the most conducive stage construction to that end, as it allows the audience to view all parts of the story, and as such lends itself to a cohesive story. Alternatively, immersive pieces tend to alienate parts of the audience

to sections of the story, such that not everyone gets every part of the story, leading to interpretations that are formulated based off of incomplete information. It is my opinion that when consuming art that tells a story, especially theatre, where anything could happen during a live performance, all parts are needed to build a coherent understanding.—Morgan Mansfield, sophomore computer science major

———◆———

The reason why I choose immersive theatre instead of a more "conventional style" such as proscenium is because theatre is live and live theatre would be an exciting experience for the audience, allowing them to explore the art of theatre from a alternative approach since this will give them a different perspective of its meaning. Immersive theatre will enable the audience to experience theatre as active spec-actors, as Augusto Boal would call it. The audience will have the opportunity to do both, observe and act becoming participants in the performance.—Daianne Ortiz, sophomore, undeclared major

What type of audience relationship would you like to create? How would you accomplish that?

What kind of production structure would your company use?

Where would you get your funding?

What audience would come to attend your performances?

How much are you charging per ticket?

What kind of training would you like your actors to have? How will you find/train them?

What is the mission statement for your theater?

INTERVIEW:

Artistic Director of Rhymes Over Beats, Patrick Blake

"I've always wanted to do new work and tell stories that weren't being told."

Courtesy of Patrick Blake

Patrick Blake is a Playwright/producer based in New York and San Francisco. He has produced: Joe Fearless, The Exonerated, Bedlam's St. Joan/Hamlet, Play Dead, In The Continuum, My Life Is A Musical. *He is currently writing the book of* Freedom, *a hip hop musical about unjust conviction. He is the founding artistic director of Rhymes Over Beats, a hip hop theater company; he is a member of The Players Club, The Dramatist Guild, and is on the board of directors of Theater Resources Unlimited.*

Since we've been talking about developing a personal aesthetic and creative process, what would you say your aesthetic is at this point in your career? How do you use your creative process to build work for your company?

My aesthetic isn't about a particular subject material or style of theater, it's just that I want to help people tell stories that are not being told in the theater. For Rhymes Over Beats, specifically for the Hip Hop world. There are all sorts of stories in the urban community that aren't being told anywhere, and what Rhymes Over Beats does is to help bring these stories out as theater pieces.

What is it that you do specifically?

We have a group of playwrights, and we have actors and directors. What we do is sit down with the rappers and the DJs and the people who write beats and say, "What's your story?" And we help them put those stories together.

For example, a photographer who's taken pictures of almost every hip hop artist in the last fifteen years has stories; we have a dramaturg in the company to sit down and structure his piece with him.

So you write urban stories and put Hip Hop music to them?

Yes, among other things. Since Rhymes Over Beats consists of every theatrical category of performer, we are able to workshop the piece in house and develop it. If you're a rapper and you sit down with one of our playwrights who helps you construct a rap musical, you don't have to go looking for a director, there are directors in the company. You don't have to go looking for actors, because there are actors in the company. You don't have to look for theatre producers to do the workshop process or to handle the financial side of things, because there are theatre producers who are part of the company. I think that's one of the

innovations in our company, that we're treating theater producers as part of the creative team in developing new work.

As the Artistic Director of a non-profit company, what is your company's mission? How does your own personal mission as a producer play a part in developing new work?

Our mission is to create Hip-Hop theater. Hip-Hop has dominated every other major category in the culture. It is dominating fashion, it's dominating music, it's dominating art. The only one that it isn't dominating is theater. I think that's primarily due to the fact that their music and our music split; our mission is to bring them back together. I think the reason we can do this and Rock n' Roll couldn't is simple: it takes five years to create a musical, and much less time for the music industry to create an album. In the same five years that it takes to create a musical that may or may not be produced, rock artists could do two platinum albums and make a ton of money.

The music industry has changed now, and albums aren't selling like they used to. Groups can't make the money like the Rock n' Roll people could make a few years ago. However, you can sit down and write a score for a musical if you're a Hip-Hop artist. The economic situation has changed. We're better able to go out and pitch to the young up and coming Hip-Hop writers to write musicals, because they're not going to be making a ton of money writing platinum albums.

So as a producer, what is your personal mission, aside from Rhymes Over Beats?

New plays! I want to do new plays and musicals. I've never been interested in doing revivals. I've always been interested in producing new work. *The Exonerated* [produced Off-Broadway in 2002] was a new play. *Freedom,* which is the hip-hop musical that Rhymes Over Beats is developing, is a new play. *In the Continuum* [2005] that I produced is a new play. I've always wanted to do new work that told stories that weren't being told. My connection to Hip-Hop is exactly that.

How did you go about forming your company? What are the steps to start a theatre company from scratch?

Get a lawyer—that's step one! There's two parts of it: the legal infrastructure, which means that you have to incorporate, you have to apply for a 501 (c) 3, tax-free status, all that. You have to turn that over to the lawyer and say, "This is what we're trying to do and this is our mission statement," and they take care of the rest of it.

In order to put the company together, I had the idea of getting a group of like-minded individuals from different disciplines—theatre directors, rappers, actors—so I asked friends who shared my vision. We assembled a few people, and those people asked people. Now we have 32 people who are part of the company. It's friends, and friends of friends. We've got a core group of people who are sort of the founding members, and we're going to look at those people in the future as people who could participate, but it will be a company decision. We'll all get together and talk about it. If we're going to get a

new rapper, for instance, we'll all get together and ask, "Does anyone have any objection to this person?" or actor, or a director. I'm trying to make the company as democratic as possible so all decisions—at least as many as are practically possible—are group decisions. I'm thinking of what it was like in the thirties, all those budding theater companies that started, like Orson Welles and groups like that. That's my model. Others as well, like Julian Beck and Judith Malina with The Living Theatre.

Is it necessary to have a physical building, to have an actual theater?

No, we don't have a building, and we don't want a building. Buildings limit you because they limit the kinds of plays you do. You say, "We can't do that kind of play because our stage isn't wide enough." Or "We can't do that play because we can't fly things easily." It's much easier to find a theater after you've written your play than to try to reconfigure your play to fit in a theater that you happen to have. Plus, you don't have to have big capital campaigns and things like that. All your effort can all go into the work itself, not into changing the toilet paper in the women's restroom.

What would you say are the necessary qualities for an Artistic Director?

Because I think of the job description as "director," I think that I'm mainly a collaborator. I have an idea, but our other collaborators dictate the details and timing. You have to sit down and say, "This actor made a really good suggestion that I haven't thought of. Let's implement it." Or, "This designer came up with something that's really fun to do. Let's do that."

What about vision? I know that you have a strong vision of what type of work you want to do.

Vision is important, as well as the ability to work well with others and collaborate. I don't care who has control as long as the work gets done. The worst thing a manager can do, I think, is micromanage. You set the vision and the goal, and you leave it up to the individual participants to implement it. Usually the people on the ground have the best view of the battlefield as it were, and can make the best decisions.

What other questions would you ask Patrick Blake if you could?

Do your questions demonstrate __specificity ___polish ___variation ____investment?

SUGGESTED ACTIVITIES

Theatre and Film Exercise

Inspired by Gob Squad's integration of theatre, film, and real life, create your own short simultaneous films with some classmates. You will need four smart phones with recording and playback capability.

Step 1. Pick or be assigned a part of the body (mouth, eyes, feet, hands) and a special element to use in at least one of your four films (water, hugs, dancing, nature)

Step 2. Plan out a two-minute continuous shot, with a different visual image each 30 seconds. Map out:

Start

30 seconds

60 seconds

90 seconds

End

THE RULES: You must all start filming at the exact same time and the start for each camera will be on the same focus, just from different angles.

You must incorporate your special element into at least part of one film of the four, but it can be included in more.

Step 3. After planning, execute your filming by synchronizing your watches and pressing "record" all together. When two minutes are up, stop filming.

Step 4. Bring your phones back into the classroom and line them up on the chalkboard railing or some other ledge where they can be displayed together.

Step 5. Press play at the same time and watch your art unfold!

Group Project

Working in groups, create a theatrical performance based on an assigned prompt. You are free to decide together what type of process and product you would like to create. Here are some possible roles for you to delegate amongst your group members:

Directing—Involves keeping the group on task, articulating a CONCEPT for the piece in collaboration with designers, and working with actors on how to deliver their lines and where and when to move.

Designing SPACE—Includes creating a plan for the physical space as well as the objects that actors will use (aka "set" and "props") that builds on the concept for the piece. Your plan should be a visual one (i.e., drawings, pictures, collage, 3D model).

Designing SOUND—Creating a soundscape for the piece by selecting and/or composing music that builds on the concept for the piece, and deciding when and how that music should be played. Your plan should be a list of cues and corresponding music, as well as samples of the music itself.

Designing LIGHTING—Building on the concept for the piece, decide how the environment can be enhanced through the use of theatrical lighting. Where should the most light be focused and what should be in shadow? What colors could accentuate mood, create a feeling of time and atmosphere? Your plan should be a visual one (i.e., drawings, pictures, collage).

Designing COSTUME/clothing—Decide what clothing each actor should wear. Consider practical issues such as what physical demands are put on the performer, as well as how the concept can be communicated through clothing. Your plan should be a visual one (i.e., drawings, pictures, or a collage).

Acting—You will be performing the piece in front of the audience. Acting involves careful preparation and rehearsal. You can decide if you would prefer the more psychological "inside-out" approach, or focus more on the physical demonstration of character in the "outside-in" in conversation with the director and other actors (if there are any). There should be consensus in the group about how best to prepare.

Playwriting—Involves creating the adapted text for performance. You may choose to create a narrative story out of the poem by adding dialogue and action (a playwright doesn't just write words actors say, but also can envision what they should do), rearranging, repeating, or otherwise altering the text.

Recordkeeping—also sometimes referred to as "stage managing." The person doing the recordkeeping is responsible for filling out task sheets and keeping minutes from the meetings conducted in and out of class. When a decision is made in the group, whether it is large or small, the recordkeeper should record it and be able to reference it quickly thereafter.

Designing VIDEO—This is an optional set of design tasks, depending on whether or not your group has an interest in adding video to the piece. One of the advantages of including video is it is possible to create and use it in the performance of the piece (rather than remaining theoretical). Video design builds on the concept of enhancing the piece through additional images in another medium. You may use found images/video or record your own. Your plan would be the actual video.

Dramaturgy—Depending on your concept, you may find it helpful to have someone designated to conduct and present creative research to the rest of the team. Perhaps this involves working with the video design on locating and vetting archival footage, or working with the playwright to give feedback as he or she shapes the piece, for example. This is an optional set of tasks for the project.

Which three roles are you most interested in and qualified to do? Why?

RECOMMENDED READING AND VIEWING

- You can see Robert Wilson's works at:

 http://www.robertwilson.com/current-productions/

- You can see images from Tectonic Theatre's production of *The Laramie Project* at:

 http://tectonictheaterproject.org/ttp-plays/record-of-success/the-laramie-project-cycle/

- "Glamming it Up with Taylor Mac" by Caridad Svich, *American Theatre Magazine*, November 2008. https://www.tcg.org/publications/at/nov08/taylormac.cfm

- "I Believe"

 www.taylormac.net

- "AACT: Crafting the Mission Statement." AACT: Crafting the Mission Statement. N.p., n.d. Web. 14 Apr. 2015.

Worksheets for Group Project

Group Project Task #___: Supplemental Worksheet on Concept

Group Name: Members of Group:

WORKING TITLE OF SCRIPT:

Answer the following questions to help you hone the concept for your performance piece.

1. Evoke a moment from the piece to create a sense of atmosphere. Describe.

2. Summarize the theatrical style(s) and/or artists that your group has been influenced by. What are the KEY ASPECTS of that style that are reflected in your piece? Why is it of interest to you?

3. Attach the outline of the STRUCTURE of your piece. What happens when?

4. What is the KEY THEME that you wish to explore?

5. Where is the CLIMAX in your piece? What is the moment that you are building toward?

6. How will your piece END? What visual moment will you leave the audience with? What is your last line?

7. Where is the TABLEAU in your piece?

8. Why is this piece relevant to your audience NOW? What do you want your audience to think, feel, do, after it's over?

Group Project Task #____: Initial Production Meeting

Group Name:

Group Members: 1.
 2.
 3.
 4.
 5.
 6.
 7.

Please record any absences, and the circumstances (i.e., Did the group hear from the absent person? Did he or she contribute work?)

What is the WORKING TITLE for your piece? (*It can be changed later.*)
Your working title should be connected to your concept as outlined below, so you could come back to this question.

WORKING TITLE: _____

A. OVERVIEW (skill set: directing)

Articulate your group's CONCEPT, or vision, for the piece. This could be written by the individual who is doing the directing or written by your ensemble. Every design decision should keep this central vision in mind, as it will be the unifying idea.

B. SPACE (skill set: environment and prop design)

What ideas do you have for an ideal environment/space? What objects would be important to your performance? Where is the audience going to sit? Where will you perform in relation to the audience? Will you have a proscenium, arena, thrust, or "found" space? Immersive? Will your audience be passive or interactive?

C. MOVEMENT (skill set: acting, movement, dance, choreography)

What type of movement will be used? Conventional or alternative? Dance-based, synchronized, story-telling, or dramatic action? Or a combination of different types?

D. DICTION (skill set: acting, writing, directing)

Will the actors speak or not? How will diction be constructed: dialogue, narrative story-telling, chanting/rhythmic, poetic, rap? What do you envision the text sounding like? What effect do you want to create for your audience?

E. SOUND (skill set: sound design, acting, music)

What ideas do you have for your ideal sounds/music for the piece? How can you practically incorporate the sounds that you imagine?

F. LIGHTS (skill set: light design)

What ideas do you have for an ideal lighting environment? How can you practically incorporate the lighting that you imagine?

G. COSTUME (skill set: costume design)

What ideas do you have for an ideal costume design? How can you practically incorporate the costume ideas that you imagine?

H. WRITING/RESEARCH (skill sets: writing, research, dramaturgy)

What is the state of the script for your performance? What areas of research have you identified? What areas of research are the other members of the group curious about? What style of acting preparation and rehearsal will be used?

I. ADDITIONAL PLANNING

Will you be using video design in your performance? Projections? If so, what ideas do you have in creating a video? Who in your group has the expertise to execute a video once the plan is made? What other optional tasks will your group include in order to complete the assignment? Discuss these ideas below or on the back of this page.

J. ACTION STEPS

Each group member should come up with at least one "action step" and commit to having that completed by next class. Before you can move on to the next task sheet, all designs and script should be fully formed.

Please record the "action step" commitments for each group member below and initial.

1.

2.

3.

4.

5.

6.

7.

Approved by:_____ Date:_____

Group Project Task #___: Initial Rehearsals
*In order to do this task, you must have a completed draft of your performance script

Company Name: _____

Working Title: _____

Record meetings and minutes, as well as absences. List rehearsal dates when you came together.

A. Read Through/Table Work
This is done sitting down around a table, with no movement of the performers at all. The idea is for everyone to listen very carefully to the words as they come off the page, and to discuss afterward what needs to be changed. (If your piece is movement-based, your script should include stage directions that describe the movement as best as possible.)

Answer the following questions:

1. Who is playing which role?

2. How long does your piece take to read? Does it need to be cut? Where? Added to?

3. Give a summary of the action.

4. Where is the climax? Have you kept your audience engaged and in suspense?

5. What is the resolution of your piece, if any?

6. Where are the tableaux?

B. Blocking/Scoring
Once you've had a chance to read through and discuss your draft, find a space in which to work to get the piece up on its feet.

Give three moments that, through the use of improvisation, were changed or came alive during rehearsals.

C. Inclusion of videos/music – and where are you with their production?

D. Do you use any synchronized movements? How will the audience be configured?

Approved by: _____ Date: _____

CPSIA information can be obtained
at www.ICGtesting.com
Printed in the USA
LVOW05s0354170117

521170LV00002B/2/P

9 781524 918255